LEGAL
HANDBOOK
for Photographers

THE RIGHTS AND LIABILITIES
OF MAKING IMAGES

Bert P. Krages, Esq.

AMHERST MEDIA, INC. ■ BUFFALO, NY

To my wife
Kathryn Pyle Krages

Published by:
Amherst Media, Inc.
P.O. Box 586
Buffalo, N.Y. 14226
Fax: 716-874-4508
www.AmherstMedia.com

Publisher: Craig Alesse
Senior Editor/Production Manager: Michelle Perkins
Assistant Editor: Barbara A. Lynch Johnt
Scanning Technician: Deanna Draudt
Proofreader: Donna Longenecker

ISBN: 1-58428-059-X
Library of Congress Card Catalog Number: 2001 132045

Printed in the United States of America.
10 9 8 7 6 5 4 3

Notice of Disclaimer: The information contained in this book is based on the author's experience and opinions. The author and publisher will not be held liable for the use or misuse of the information in this book.

Table of Contents

Preface

THE MATERIAL IN THIS BOOK is intended to inform about the general legal principles that apply to taking photographs within the United States. It cannot substitute for legal advice for specific situations and readers should seek counsel from a competent attorney when they need such advice. Readers should be aware that laws change and the material in this book may become outdated. Since it is impossible to describe every applicable law in a book of this nature, it should not be used as a comprehensive guide to the laws as they apply in individual states.

The Importance of Knowing Your Rights

THE PURPOSE OF THIS BOOK is to introduce photographers to the basic legal principles that govern the making of images and the practical aspects of dealing with them. For the most part, society favors the benefits that photography offers and this is reflected in legal attitudes that are mostly permissive. In cases where photography can infringe on important societal interests such as national security or protecting children from sexual exploitation, it may be strictly controlled but in most cases legal regulation is premised on balancing the right of photographers to document the world against the rights of others to enjoy their privacy and property.

While most photographic experiences do not involve confrontation or legal risk, situations do arise where failing to know one's legal rights can mean losing an image or incurring liability. Another issue faced by photographers, irrespective of the legalities, is whether there are some things they should not photograph for ethical reasons. Common ethical issues include the exploitation of subjects and how to deal with the potential to misrepresent apparent truths. Unless photographers understand the basic legal and ethical issues associated with making images, they risk not only running afoul of the law but also violating personal ethics.

○ Why You Should Know About the Law

Photographers who do not understand their most basic rights about what, where, and when they can photograph tend to approach legal issues with blissful ignorance, extreme caution, or reckless abandon. A mother who photographs her two-year-old son playing naked by a lawn sprinkler may assume the innocuous nature of the images will keep her out of trouble. An environmental consultant may forgo tak-

For the most part, society favors the benefits that photography offers.

ing photographs of a hazardous waste site for fear that it is somehow unlawful to do so. Daring and foolish souls may brazenly cross the lines of propriety to obtain exclusive images of matters such as a celebrity's private activities (attorneys occasionally refer to these photographers as "defendants"). Each of these photographers may suffer as a result of their approach to the legal issues associated with photography.

Insight into the law can make you a more effective photographer because it enables the exercise of judgment that allows you to achieve your objectives—even in difficult or risky situations. For example, people can better handle confrontations when secure about their rights and knowledgeable about their potential remedies should those rights be violated. Photographers who know the law are also better able to find options that minimize their legal risks, such as composing shots to exclude incidental but legally problematic subjects. An understanding of the practical aspects of the legal system can be used to advantage to get images where other photographers fail. For instance, many people assume that the most common motive behind filing lawsuits is to recover money and are unaware that emotional issues are the root of many kinds of litigation. Showing sensitivity and simple courtesy are not only effective tools for avoiding confrontations and lawsuits; they can be skillfully used to make opportunities denied to the less knowledgeable.

> Insight into the law can make you a more effective photographer.

While understanding legal principles can help you deal with the legal aspects of taking photographs more effectively, you should also realize that no book can substitute for informed advice from counsel in situations that involve significant legal risk. One reason for this is that the law has not always evolved to the point where it is possible to determine clearly how it applies to a particular situation. Furthermore, laws vary among jurisdictions and change over time as legislatures enact new statutes and courts modify legal doctrines to reflect modern sensibilities. These and other factors can make assessing how the law applies to specific facts and locations difficult even for expert practitioners. In cases where the law is unclear or the potential consequences substantial, it is in your best interest to consult with an attorney for advice on the legal risks and how to avoid them.

○ How Laws Are Made and Enforced

A civil procedure professor once commented that learning about the law is similar to eating sausage. If you like it, then don't watch it being made. In other words, the operation of the legal system is not always consistent with the common perception of how it should

work. Since photographers must apply legal principles to real situations, an understanding of how laws regulate conduct within our society is an important step to managing the legal aspects of making images. However, it is also important to understand the mechanisms by which laws are created and enforced, since a principle is meaningless if it cannot be put into action.

As a starting point, the legal system's role in society is to define enforceable conduct and to provide mechanisms for resolving disputes. The three basic kinds of laws are statutes, administrative rules, and the common law. Statutes are enacted by legislatures but interpreted by the courts. Administrative rules are promulgated by government agencies pursuant to statutes that give them this authority. The common law has been fashioned by courts based on the enforcement and application of ancient customs and judicial precedents.

The federal government and states have their own legislatures, which means that many different laws are enacted. Federal statutes usually apply to conduct in all the states. For example, the statutes that regulate the photography of currency apply equally to all citizens of the United States regardless of whether they live in Alaska or Wyoming. However, laws enacted by the states generally apply only to conduct within that state. This means that someone who conceals a camera to photograph private activities in Atlanta can be prosecuted under the Georgia statute prohibiting such acts but not under the Hawaii law that prohibits the same.

Administrative rules are generally limited to specific jurisdictions or activities that affect a particular agency. For instance, a city ordinance requiring a permit to photograph a commercial assignment in a city park will be limited to that city and a regulation issued by the U.S. Postal Service regarding photography inside of post offices will not apply to other government buildings. Sometimes regulations are issued that interpret or define the scope of requirements described in a statute. An example is the regulation issued by the Department of the Army regarding photography of military decorations and service medals.

Although statutory and administrative laws vary substantially across the United States, in many cases it is reasonably easy to look them up. These laws are usually available in local libraries and if not, can be obtained from the appropriate government office. Many states and the federal government have made access to their statutes and regulations available on the Internet where they can be searched electronically. Typical kinds of laws that can be looked up in this manner include city ordinances that set forth rules that apply to public side-

The legal system's role in society is to define enforceable conduct . . .

walks and parks, statutes that regulate concealed cameras, and court rules that govern the photography of judicial proceedings.

The common law encompasses doctrines such as trespass and contract and is applied by state and federal courts. Although the states and the federal government have separate court systems, the federal courts are generally required to apply the law of the state in which they are located when deciding common law issues. For instance, a federal court hearing a right to privacy case in California would apply the California doctrine of privacy rights while a federal court in Virginia would apply the Virginia doctrine. As is the case with legislative law, the common law may be applied differently among the states although the ancient roots of the common law tend to moderate such differences.

Looking up the common law is more difficult than researching statutory requirements since this body of law is set forth in the form of published decisions. However, even though the states have their own versions of the common law, they tend to follow the same general principles for doctrines such as trespass and contract. Some common law doctrines can vary significantly among the states, such as the

> The common law encompasses doctrines such as trespass and contract.

The common law is set forth in thousands of volumes of published court decisions that require specialized skills to research.

doctrines that govern privacy rights. In addition, common law doctrines are sometimes modified by statute. Researching common law issues takes a fair amount of knowledge and effort and is not recommended for those who lack the necessary training. However, general knowledge of common law principles should suffice to keep most photographers out of trouble, provided they refrain from photographing subjects under questionable circumstances or seek advice from counsel beforehand.

As an example of how courts apply the common law to specific situations, suppose someone in Oregon is waiting for a flu shot and photographs his children playing in the waiting room at a medical center. The pictures are posted on the family web site and several months later, the photographer is sued for invasion of privacy by a patient of the clinic who claims she appears in the background of one of the photographs. Although such a claim may appear frivolous, arguments can be made that the photographer is liable for invading the other patient's privacy. The Missouri Supreme Court ruled in 1942 that a magazine photographer violated the privacy rights of a patient with a dietary ailment who expressly objected to being photographed in her hospital bed. Similarly, the Maine Supreme Court ruled in 1976 that a physician violated the privacy of a dying man by taking unauthorized photographs.

Some legal commentators maintain that these cases represent the principle that medical patients cannot be photographed without their consent. However, while Oregon courts would likely consider these cases, they are not required to follow them since they do not establish the law in Oregon. Furthermore, an Oregon court could find that taking an unauthorized photograph of a patient in a waiting room does not violate the kind of privacy interest the legal doctrine is intended to protect. On the other hand, Oregon law does favor some right to privacy and would give serious weight to the fact that other states have decided that the privacy of medical patients warrants more protection from photography than do other subjects. Since the Oregon courts have published no decisions regarding the privacy rights of patients in waiting rooms, an attorney would necessarily have to make an educated guess about how a judge would decide the case.

Laws can be enforced criminally or civilly, depending on how they were enacted.

Laws can be enforced criminally or civilly, depending on how they were enacted. The objective of criminal laws is to deter misconduct by punishing violators. The typical sanctions are monetary penalties and incarceration. Laws that provide for civil remedies are generally intended to compensate victims for their injuries. Criminal laws and some statutes and regulations can only be enforced by the govern-

ment. For example, a statute that makes it a criminal offense to photograph the presidential seal absent authorization could be prosecuted by the federal government but not by private citizens. Common law actions can be enforced by private citizens but only on their behalf. For example, if someone trespasses onto your neighbor's property to get better access to photograph your family, your neighbor could sue them but you could not. In some cases, conduct can violate criminal and civil laws simultaneously. For example, a photographer who refuses to leave the lobby of a hotel after being told to leave by the management may be prosecuted by the state for criminal trespass and sued by the hotel for private trespass.

The Mulberry Tree Case. Even simple laws are subject to twists that complicate their application and enforcement. For example, the law of trespass appears reasonably straightforward in that it prohibits one from entering another's property without permission. However, the substantive aspects are often overwhelmed by the procedural and practical aspects of taking a matter to court. For instance, there is the cost of retaining counsel, the possibility that judges and juries will make serious errors, and the difficulty of making decisions in the face of uncertain outcomes. The following scenario illustrates how a simple trespass case involving trivial conduct can combine with fortuitous circumstances to cause legal trouble for a photographer.

Assume that a suburban naturalist wants to photograph some birds who appear to be building a nest in a mulberry tree next to a house. The photographer asks a young woman (actually, she is the fourteen-year-old daughter of the homeowners but looks much older) if he can set up his tripod next to the house and take some pictures. She tells him he can take pictures whenever he wants and leaves to visit friends. Her mother drives up thirty minutes later and, thinking that the photographer is trying to photograph through her daughter's bedroom window, starts hitting him. She is not appeased by the photographer's explanations that he only wants to photograph mating rituals and that he has permission to be in the yard whenever he wants. The photographer stomps off—only after vowing to return when the mating process becomes more active. The mother, who has been undergoing psychiatric treatment for severe anxiety, deteriorates after the incident and is hospitalized for several weeks under heavy medication.

The outraged homeowners sue the photographer for trespass and invasion of privacy and seek compensation in the amount of $500,000 for emotional distress and medical bills. The photographer files an answer denying that he trespassed or invaded their privacy and counterclaims for assault in the amount of $100,000. Attempts to

Assume that a suburban naturalist wants to photograph some birds . . .

settle fail when the homeowners refuse to settle for less than $300,000 and the judge sets the matter for trial. Although in many respects this is a straightforward case, the judge and jury make the kind of errors that typically occur in trials. The most significant error by the judge is an evidentiary ruling where he allows the homeowners to testify about their hospital bills but refuses to let them present a document that summarizes them. Later in the trial he decides to back off a little bit and allows the homeowners to submit one hospital record that reflects an interim charge of $5000. The jury errs in applying the law after misunderstanding the following instruction that was rendered in the judge's most studied monotone: "A trespasser is a person who enters or remains on the premises in possession of another without a privilege to do so and a possessor of the premises has no duty to keep the premises in a safe condition and a trespass occurs when there is an interference with the right of possession. . . ." Having heard this once through and without the opportunity to ask for clarification, the jury deliberates for five hours and finds that the photographer committed a trespass despite getting permission from the daughter and that the homeowners are not liable for assault because they were defending against a trespass. They award the homeowners $5000 mainly because they do not believe the incident contributed greatly to the hospitalization.

A particular set of facts can lead to a middling outcome.

The homeowners do not know the basis for the verdict and assume the jury mistakenly believed the hospital record the judge allowed into evidence was a summary of their total expenses. The photographer also disagrees with the judgment because he believes that the mother was legally required to ask him to leave before assaulting him and that he reasonably relied on the daughter's permission to enter the property. Although both parties are unhappy and have reasonable grounds for appealing the court's judgment, they decide not to appeal because it is too difficult to predict who will win.

This example shows how a particular set of facts can lead to a middling outcome but, of course, many others are possible. For instance, had the jury believed that the stress of the incident contributed significantly to the hospitalization, they could have awarded a large verdict against the photographer. Similarly, had they understood the judge's instruction better, they may have ruled in favor of the photographer and possibly awarded him a small amount of money. In any case, the moral of the story is that sensitivity to legal and emotional issues can help photographers avoid getting entangled in legal processes. Had this photographer understood the law and the potential consequences better, he could have considered foregoing the opportunity to take the photographs, verifying the age of the daugh-

ter and waiting to get permission from a parent, or at the very least treating the mother respectfully when the confrontation began. Arguing with the mother was particularly stupid, and sensitivity to her perspective could have changed the outcome of the incident. With a better grasp of the practical and legal aspects, the photographer could have obtained his images while avoiding much aggravation and expense.

O Legal Aspects of Publishing Photographs

The law associated with publishing photographs is far more developed than the law associated with taking them since media producers attract more attention and have deeper pockets than most photographers. Although this book focuses on the law of taking photographs, the legal aspects of publishing photographs are summarized to help you to understand why laws rarely restrict the actual taking of photographs. This information will also be useful to photographers who publish, display, or exhibit their work.

Publication means the reproduction and distribution of materials. Examples of how photographs may be published include reproducing them in printed media, posting on a web site, exhibiting on a wall, or showing them to friends. As a practical matter, most lawsuits involving the publication of photographs are filed against the print media although litigation against web site owners is becoming more common.

Two aspects of publishing law that photographers need to know to avoid liability for publishing photographs are the doctrines that establish privacy rights and the tort of defamation. There are four kinds of privacy rights: (1) intrusion upon seclusion, (2) appropriation of name or likeness, (3) publicity given to private life, and (4) placing a person in false light. The privacy right that has the most relevance to the taking of photographs is the intrusion upon seclusion tort since photographers can be liable for intentionally intruding on someone's private affairs in a highly offensive way irrespective of whether the photographs are published. This tort is discussed in detail in chapter 3. Photographers cannot be liable for violating the other privacy rights or for defamation unless the photographs are published.

Perhaps the most discussed tort affecting a privacy right is the tort of appropriation of name or likeness (also known as the right to publicity). Under this tort, anyone who uses the name or likeness of another without their consent to gain some commercial benefit can be liable. The most common situation is the unauthorized use of an image of someone in an advertisement to promote a product or

Photographers can be liable for intentionally intruding . . .

enterprise. This is why advertisers require model releases when identifiable people are portrayed in advertisements. To constitute appropriation, it is necessary to attempt to capitalize on the reputation, prestige, or similar values associated with the subject. Since editorial uses are intended to provide information rather than assert sponsorship, they are not considered to appropriate someone's reputation and photographs may be published in these contexts without the subject's authorization. For example, using an unauthorized photograph of a celebrity to illustrate a magazine article would not be considered an appropriation since no endorsement of a product or service is implied.

Under the tort of publicity given to private life, one can be liable for publicizing the private affairs of a person if they are not of legitimate concern to the public. *Publicity*, as the term is used in this tort, means the widespread dissemination of information so that it will likely become public knowledge. Showing an intimate photograph taken without someone's permission to a few people would not be considered publicity given to private life, although publishing it in a newspaper or posting it on the Internet would be. The interests protected by this tort are limited to matters that the subject would reasonably expect to be kept from public view and that would be highly offensive to a reasonable person if disclosed. The tort does not protect against publicity given to matters of legitimate public concern. This means that persons who become newsworthy either by assuming a prominent social role or becoming enmeshed in newsworthy events may lose their right to privacy to the extent that their private affairs are relevant to legitimate news.

The torts of placing a person in a false light and defamation are closely related. Defamation is the damaging of a person's reputation by a statement that is known or should be known to be false. Placing a person in a false light requires a false representation but does not necessarily require damage to the plaintiff's reputation. Like defamation, the person accused of placing another in a false light must either know about or recklessly disregard the probable falsity of what is being represented. When photographs are found to defame someone or to have placed them in a false light, it is usually because the photograph is used to illustrate text in a way that falsely and offensively depicts them. For example, assume that a newspaper editor instructs a press photographer to go out and take some photographs of teenage prostitutes to illustrate a forthcoming feature on teen prostitution. After driving around the community, the photographer sees and photographs a man stopping his car next to a street corner and picking up a racily-attired teenager. There is nothing unlawful about

The torts of placing a person in a false light and defamation are closely related.

taking such a photograph. Furthermore, there is nothing unlawful about using the photograph to illustrate the feature article if the man is in fact picking up a prostitute since this would be a truthful portrayal. However, if the man is picking up his daughter after a rehearsal for a high school play, the newspaper and the photographer risk being liable since portraying them as engaged in prostitution would be false and highly offensive. Whether they would actually be found liable would depend on whether they reasonably assumed the girl was a prostitute. Among the factors a jury might consider are the location, time of day, and other circumstances connected to the photograph. If the photograph were taken on a street known for the solicitation of prostitutes, a jury might well find the assumption was reasonable. If taken in front of high school in a neighborhood with no history of prostitution, the newspaper and photographer are at serious risk of being held liable.

A jury might well find the assumption was reasonable.

2 Access

\mathbf{A}LTHOUGH MOST PHOTOGRAPHERS UNDERSTAND the basic laws that govern the right to enter and remain on property, knowing the nuances can greatly assist in gaining lawful access and avoiding erroneous and potentially costly decisions. This knowledge is particularly useful in situations where the legality of being able to take photographs depends on the location. For example, is it lawful to park on the shoulder of an interstate highway to photograph a rainbow? Is it alright to enter and photograph a vacant property that is not posted against trespassing? Does a forklift driver have the authority to let you take photographs inside a lumberyard? Being able to answer these kinds of questions can be critical to determining your right to take photographs in specific locations.

O Access to Private Property

There is no general legal right of access to private property for the purpose of taking photographs, which means that photographers must obey the same laws that apply to the general public. Since private property owners have the right to exclude others from their property and to limit the activities of those they allow to enter, photographers face liability for trespass if they enter another's property without permission or disobey the conditions of that permission. The law recognizes that in many cases people may rely on the customs of the community that establish when they have implicit permission to enter someone else's property. It is a universal custom that the public is allowed to enter the public spaces of commercial establishments such as restaurants and stores. It is likewise a universal custom that members of the public may not enter places such as residential units or industrial properties without explicit permission to do so.

In some cases, it is difficult to determine whether the owner allows the public onto a property and some judgment must be exercised.

The right to exclude others from your property is time honored.

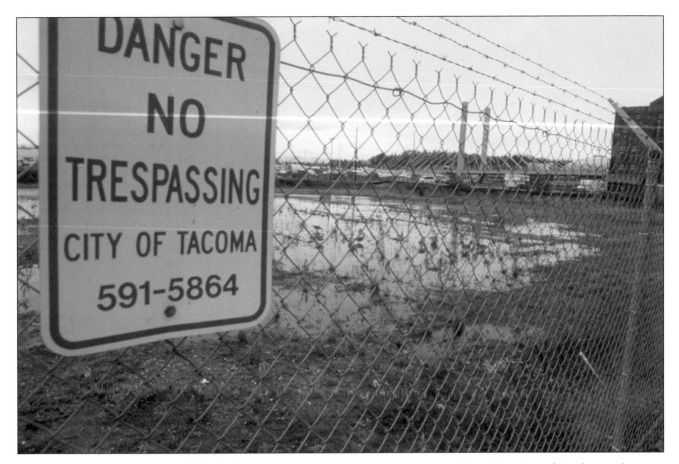

For example, undeveloped properties sometimes show signs of public access such as paths or recreational structures. Although such activities may indicate that the owner allows the general public to enter the property, there is no legal presumption that landowners have given such consent. Furthermore, owners are not required to post signs prohibiting trespassing if they do not want the public entering their property. When the local custom is that people may use privately owned open space for general recreation such as hiking, you may reasonably assume that you may enter to take photographs unless informed otherwise. However, such decisions must be made at your own risk since many communities do not have clearly defined customs in this regard. Even a good faith but mistaken belief that you have permission will not protect you from a charge of trespass unless the mistake is the fault of the property owner. For example, you are still trespassing if you enter onto the wrong property because your client gave bad directions. Furthermore, the fact that you do not intend to cause harm does not excuse a trespass.

Photographers should be aware that the law of trespass is not limited to bodily entries. Extending a camera over and across a fence will constitute a trespass even though the photographer is standing out-

Entering fenced and posted property without permission is trespassing. Even sticking a lens through a chain link fence will violate the rights of landowners to exclude others from their property.

ABOVE: Some property owners freely allow public access, albeit with conditions.

RIGHT: Sometimes it is difficult to determine whether an owner allows the public to enter a property. This former industrial property shows signs of public use and the entrance is not posted against trespassing.

While fences can often be construed to mean that public entry is prohibited, the gate to this property is unlocked and has been left wide open.

side the fence line. Passing over a property for the purpose of aerial photography can constitute a trespass when it infringes the immediate reaches of the airspace above the property and annoys the occupants. Similarly, for those of you who are willing to crawl through sewers, a subterranean entry onto someone else's property is also a trespass. However, you are free to photograph anything on some one's property that is in public view even though you may be prohibited from entering the property itself.

There are a few legally recognized instances where you may enter or pass over property, even without permission. Using a navigable stream in a reasonable manner is not a trespass even if the streambed is privately owned. Although what constitutes reasonable conduct is a factual issue, most courts would hold that taking photographs of private property from a boat is not trespassing.

Another instance where permission to enter private property is not necessary is when the photography is necessary to mitigate a public disaster or serious harm to another person. This justification is limited to exceptional situations such as when taking photographs will facilitate the apprehension of a criminal. It does not extend to photography that is not necessary to prevent a serious harm even if it relates to a beneficial purpose such as news coverage. For example, a photographer who sees a child struck by a hit-and-run driver would be legally justified in entering private property to photograph the fleeing vehicle since this evidence might identify the guilty driver. However, the photographer would not be justified in entering private property if the purpose was to get a better photograph of the victim to publish in a newspaper.

Photographers who enter property with permission should also be aware that owners are free to place express or implied limits on photography. Determining the limits of implied permission to take photographs often requires judgment even when consent has been granted for other purposes. For example, one can lawfully enter a restaurant to dine but whether one has implicit permission to take photographs will depend on the nature of the establishment. One could reasonably assume that a fast food restaurant will not mind patrons taking a few photographs of their family since this activity is compatible with informal dining oriented to families. However, it would be unreasonable to assume that a formal restaurant will allow you to photograph celebrity patrons unless you have explicit permission.

Photographers are sometimes tempted to misrepresent why they want to enter a property in order to get permission. Irrespective of the ethical ramifications, falsely representing one's purpose for entering a property may invalidate the consent and expose you to liability

Owners are free to place express or implied limits on photography.

Whether someone has permission to take photographs often depends on the circumstances. One may reasonably assume they can take photographs at informal restaurants unless told otherwise.

for trespass. Most jurisdictions hold that one cannot even misrepresent the reason for wanting to take photographs in order to obtain consent from the owner. For example, a photographer would still be trespassing if he or she tells the property owner that the photographs would be used to illustrate an article on tourism when the real purpose is to gather evidence to be used in a lawsuit filed against the owner. A few courts have held that fraudulently inducing consent by misrepresenting how the photographs will be used does not constitute trespass but that the photographer can still be held liable for other torts such as fraud.

Mistaken consent may constitute no consent at all. For example, a property owner may wrongly believe that the photographers accompanying police are there for the purpose of recording evidence as part of an investigation. If the photographers are actually working for the media and did not obtain permission from the owner, they can be liable for committing trespass. Therefore, photographers should be careful not to assume that the absence of objections implies consent if the circumstances are such that the property owner could reasonably be expected to misunderstand why the photographer is present.

Another limit on permission to enter a property is the time period for which it is effective. The implied consent to enter a restaurant is obviously limited to the hours during which the restaurant is open to

the public. In other circumstances, exact time limits may not be specified but are assumed to be for the time reasonably needed to accomplish the purpose underlying the entry. Unless specifically granted, permission to enter a property does not extend to future entries. This means that if an owner agrees to let you onto his or her property to photograph something, you should not assume that you may enter in the future.

It is important to ensure that the person giving permission to enter a property has the legal capacity to do so. Whether a person has the capacity to allow you onto a property will depend on his or her relationship to the owner and the ability to appreciate the nature, extent, and consequences of the consent. Some people, such as very young children and severely mentally impaired persons, are presumed not to have the legal capacity to give permission. Even older children and less impaired persons may be deemed not to have the capacity to consent, depending on the circumstances. When seeking entry to a property, it is better to seek consent from persons who are competent adults and bear an appropriate relationship to the owner.

The authority to grant consent can be critical when a photographer is seeking permission to enter a property from someone other than the owner. When seeking permission, you should establish whether the person has authority to allow other people access to the property. In many cases, one may reasonably infer that people such as the managers of commercial establishments have such authority. Among the factors to consider in determining whether someone has the apparent authority to allow an entry are the stature of the parties, the nature of the property, and the general customs that apply. It is important to understand that not all employees have the authority to allow you onto the premises. For instance, cafeteria workers at a nuclear power plant are not authorized to let visitors enter the control room. When in doubt as to whether someone is authorized to allow access, you should seek permission from someone who is more likely to have authority.

Another issue is whether public officials, such as police and fire officers, can allow media photographers onto private property to cover searches, fire fighting, and similar activities without permission from the owner. Although inviting the media to cover police activities has been customary in parts of the country, government officials do not have the authority to allow the media or independent photographers to enter private property without the owner's permission. This means that a photographer could be liable for trespass, even when a government official said they could enter. Most attempts to argue that traditional practices constitute implied consent have failed.

> **Not all employees have the authority to allow you onto the premises.**

A notable exception occurred in 1976 when the Florida Supreme Court ruled that a newspaper photographer reasonably relied on permission given by fire officials when he entered a private residence and photographed the outline of a deceased teenager. However, most if not all other courts that have faced this issue have ruled the other way.

Sometimes photographers encounter situations where the person who objects to an entry may not have the authority to exclude others from the property. Since the scope of authority to refuse entry is the same as the authority to grant it, third parties have no right to order you off a property unless the owner has given them authority to do so. Among the more common situations are businesses who attempt to ban parking on streets that abut their properties and tenants at complexes such as shopping malls who attempt to expel persons from common areas. In some cases, whether the owner has given implicit authority to a tenant regarding control over activities in common areas is unclear since such matters are not always addressed in lease agreements. Likewise, cities and counties sometimes restrict parking in front of businesses at the request of the owner. It is often prudent to contact the property owner or government agency directly when seeking permission to photograph in common areas or where a private entity has posted signs that limit public use of public properties.

Although owners and their agents may use force to evict trespassers, they must first ask the offending person to leave unless the circumstances indicate that the request would be futile. Once a photographer has indicated they will not honor a request to vacate the property, the owner and his agents are legally entitled to use the level of force reasonably necessary to remove the trespasser. However, they are not entitled to seize a photographer's film or equipment. Even when photographers agree to vacate premises after trespassing, they can still be sued for damages. Although photographers rarely damage property when they trespass, courts may allow property owners to recover for the discomfort, inconvenience, and emotional distress caused by an unauthorized entry. Photographers who enter properties posted against trespassing or who disregard an owner's request to leave may be liable for criminal trespass as well. In addition, using force to resist a lawful eviction can result in liability for assault.

Using force to resist a lawful eviction can result in liability for assault.

O **Photography in Public Places**

The government can restrict photography only if an overriding government interest can be shown, which means that photographers

have a qualified right to take photographs when in a public place. Whether or not a particular government interest is sufficiently compelling to override the right to take photographs will depend on the nature of the public place. Governments have less power to restrict photography in areas traditionally open to public expression, such as city parks and sidewalks, than they do in places where government business is more prone to disruption. Not all properties owned by the government are public places and these areas may be closed to the public altogether. Examples include military bases, prisons, and the areas of government buildings that are not open to the public.

The most common reason for restricting photography on government-owned property is to avoid disruptions to legitimate government functions. For example, judges can prohibit photography in courtrooms to preserve dignity and decorum, and building administrators can regulate photography in government buildings to avoid interference with government business. Sometimes governments will regulate only certain types of photography. For example, some agencies and cities require permits for commercial photography when extensive props, crews, or models are used on public properties; they

City sidewalks are traditional public forum areas where the government must show a compelling reason to restrict expression.

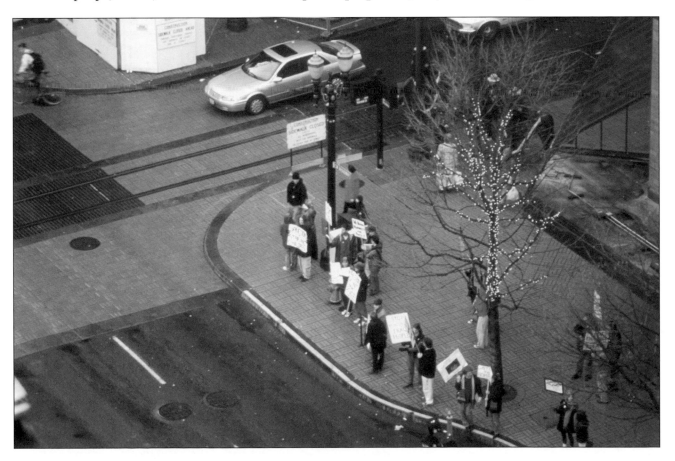

administer but do not otherwise restrict photography. For example, the National Park Service requires motion picture photographers to obtain permits if the filming will involve professional casts and settings and requires still photographers to obtain permits before photographing products and models for the purpose of commercial advertising. Neither the National Park Service nor the U.S. Forest Service require permits for general photography, even if the images may later be marketed.

No permits are needed to take photographs at national parks and forests except in a few limited situations where professional casts or settings are used or when products and models are photographed for advertising purposes. However, photographers must comply with all other permit requirements.

The most open public places are those where members of the public have traditionally been accorded the right to express themselves. Established examples of these public forums are city sidewalks and public parks. Some cities have enacted ordinances that encourage the maximum public use of facilities such as parks. While the government can impose restrictions when necessary to protect public welfare, these are typically addressed to the public at large, and rarely affect photography specifically. The primary restrictions for activities on public sidewalks are prohibitions against obstructing free passage and access to properties adjoining the sidewalk. The ordinances and rules that apply to city parks typically prohibit things such as littering, unreasonable noise, and vandalism.

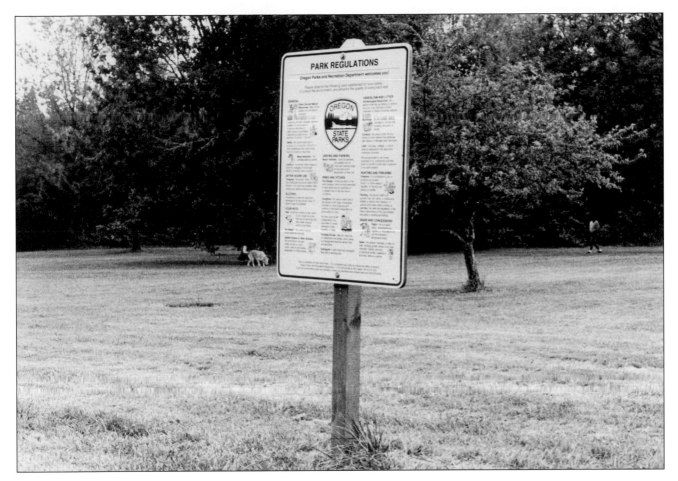

Although normal photographic activities should not cause problems in public forum areas, extreme or suspicious behavior could expose a photographer to prosecution under disorderly conduct and loitering laws. Disorderly conduct laws prohibit people from engaging in any behavior that causes inconvenience, annoyance, or alarm through disruptive behavior. These statutes usually require a substantial level of interference with another person's activities to be actionable. For example, taking a few photographs of someone in a public place will not constitute disorderly conduct even if the person is annoyed. Extreme behavior, such as repeatedly taking close-ups despite someone's objections, could constitute disorderly conduct depending on how the statute is written. Photographers have also been held liable for disorderly conduct by refusing to obey reasonable orders from police officers at accident and crime scenes.

Normal photography is unlikely to result in a prosecution for loitering, although in some circumstances you might be questioned by police about why you are hanging around a particular location. The intent behind loitering laws is to give the police an enforcement tool to prevent crime before it happens. Since crimes such as prostitution, drug dealing, burglary, and pedophilia are typically characterized by

Although park regulations can be extensive, photography is almost always allowed.

persons standing or wandering about with no apparent purpose, many municipalities have enacted ordinances that attempt to make being present in an area for no legitimate reason a crime. Courts have declared many of these ordinances unconstitutional because they fail to distinguish between unlawful and constitutionally protected activities and thus give the police the discretion to arrest almost anyone on the streets. The ordinances that have withstood judicial challenge usually describe the prohibited conduct more specifically by requiring an explicit connection to unlawful activities such as prostitution or drug dealing.

As a practical matter, photographers are unlikely to run into problems with loitering ordinances unless they are present in places at unusual times. However, there is nothing illegal about being present in public places at any time except when specific areas have been declared closed to the public, such as city parks after hours. Keep in mind that the enforcement of these ordinances is usually motivated

by concerns over street crime, drug dealing, and prostitution, and a credible explanation for your presence (i.e., photography) can alleviate police concerns. In many cases, the police will be responding to complaints filed by residents or workers concerned about suspicious activity. If you are in a place at unusual hours and see a police officer approaching, it is best to remain where you are since leaving the scene will make you look more suspicious. Once you have explained that you have a legitimate purpose in being present, most police officers will leave you alone. Should the police insist that you move on against your wishes, you run the risk of being arrested for loitering.

As noted above, photography in public places other than public forums can be restricted if it can substantially disrupt the legitimate function of the facility. Many government agencies have promulgat-

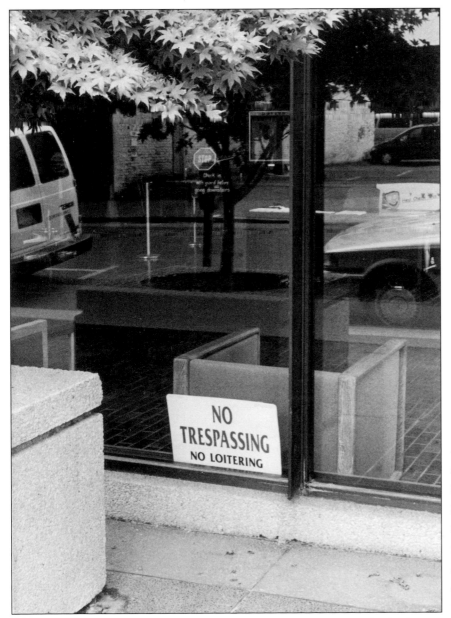

Private parties have no legal authority to prohibit loitering on the public sidewalks adjoining their properties. Although signs that purport to prohibit loitering may not have legal effect, they can indicate that the property owner may be more prone than most to summoning the police.

ed regulations that govern photography in the publicly accessible spaces under their jurisdiction. Some agencies are very permissive about photography while others impose strict requirements. The tightest restrictions tend to be imposed on military bases, security installations, and concert halls. For example, cameras are prohibited at facilities operated by the National Security Administration unless specially authorized by the Director of Security or a designee.

Even activities that are open to the general public may be subject to substantial restrictions, even though photography will not jeopardize national security. Cities often prohibit cameras at concerts held in their auditoriums at the insistence of promoters and artists who want to control images for marketing reasons. The Securities and Exchange Commission and the Nuclear Regulatory Commission require advance approval before meetings of their commissioners can be photographed. Other agencies, such as the Tennessee Valley Authority and U.S. Postal Service, are more comfortable with the prospect of unapproved images and specifically allow photography at their public meetings so long as it is not disruptive.

Some agencies regulate photography depending on whether it is done for personal, news, or commercial reasons. Photography for personal purposes tends to be the least restricted. For example, general visitors to presidential libraries may take photographs in areas open to the public, but photographs intended for news, advertising, or commercial purposes can be taken only after a library director approves the request. Some agencies, such as the U.S. Postal Service, take the opposite approach by explicitly allowing news photography in the public areas of post offices but requiring other photographers to seek permission. Commercial and advertising photography at many government properties requires a permit or other permission from an agency. Photographers seeking to do commercial photography at the National Arboretum or commercial aerial photography over national parks must pay a fee and provide advance notice. Advertising and general news photography are prohibited outright at the National Archives Building and the Washington National Records Center.

Although regulations governing photography are not commonly displayed, they are available in administrative compilations such as the Code of Federal Regulations and state administrative codes. Those who are disinclined to look up the regulations can call the public affairs offices of the appropriate agency and ask what requirements apply to photography. However, the risk in doing so is that there is no assurance that you will get the proper information. Government employees are not always familiar with the regulations implemented

Photography for personal purposes tends to be the least restricted.

by their agencies and sometimes dispense advice that is too restrictive or permissive. Since agencies are rarely bound by erroneous information provided by their employees, you rely on informal advice at your own risk. For these reasons, it is better to review the applicable regulations yourself than to rely on an employee's summary.

Many government-owned or -operated facilities are not governed by formal regulations or ordinances. For example, photography is rarely restricted in areas of public accommodation such as public transit terminals, airports, and train stations. Some government facilities, such as concert halls and convention centers, are operated essentially as private enterprises. When the government operates in a proprietary capacity, it is as free as any other private entity to restrict photography.

Schools present a special issue regarding access since they are often open to the public for some activities but closed for others. Most schools strictly limit access while in session to avoid disrupting classrooms and to protect students. Any photography done on school grounds while classes are in session will require permission from school officials. Sometimes school officials assert that they cannot allow photographers onto school grounds because of the Family Educational Rights and Privacy Act. While this act prohibits schools from releasing educational records without a parent's permission, it does not regulate photography. Extracurricular activities, such as sporting events and performances, are generally open to the public, and schools usually allow photography although they are within their rights to impose restrictions such as the use of flash. Many schools make the exterior grounds open for public use after school hours for recreational activities and public events. These activities are open to photography.

Streets and highways are open to the general public but are regulated by vehicle and traffic codes. The laws regulating the use of streets and adjacent shoulders vary by state and locality but can be determined easily enough by looking them up in the appropriate vehicle code. Not surprisingly, vehicle codes generally prohibit pedestrians from positioning themselves in the portion of roads traveled by vehicles. Most vehicle codes prohibit parking on shoulders of thruways such as interstate highways, freeways, and expressways, except during emergencies such as a vehicle breakdown. However, it is usually permissible to park and take photographs from the shoulders of other roads and highways provided you do not obstruct fire hydrants, crosswalks, or driveways.

Public Places: Approaches to Street Photography. One of the most interesting forms of photography involves recording people engaged

Photography is rarely restricted in areas of public accommodation.

ABOVE: Photography is almost always allowed at places of public accommodation such as airports.
LEFT: Vehicle codes will generally prohibit stopping on the shoulder of interstate highways for the purpose of taking photographs.

in everyday life in public places. Street photography, as this genre is called, has a rich history. Practitioners such as Henri Cartier-Bresson and Garry Winogrand have produced classic images that make the commonplace appear unusual and the strange appear common. While styles of street photography vary, the genre has the common aspect of capturing candid or random actions involving people whom the photographer does not know.

One of the factors that makes street photography interesting is the connection of the photographer to the scene. Much of street photography is done close to the subject using wide-angle and normal focal length lenses, although a few favor using long lenses to put distance between themselves and their subjects. Since street photographs are not staged or modeled, success can depend on being able to interact with strangers or to remain unnoticed by blending into the background of a scene.

Many street photographers favor getting close to their subjects, in which case they are likely to be noticed. This approach takes a fair amount of bravado and is not for introverts. The means by which street photographers deal with approaching their subjects is reflected in the diverse types of images they produce. Not surprisingly, the attitudes and methods associated with close-up street photography vary. In large part, styles of street photography depend on the individual attitudes of photographers, the subjects that attract them, and what they want to show.

One school of thought maintains that it is unethical to photograph people without their permission. Photographers who subscribe to this philosophy assert that the best way to photograph the street is to be friendly and open about what you are doing and to be willing to meet and talk to the people you are photographing. The main benefit attributed to this approach is that becoming accepted as part of the street scene allows one to become less obtrusive, resulting in photographs that are honest depictions of persons and activities on the street. In addition, many maintain that it reduces the chance of being assaulted by unwilling subjects. The downside to this approach is that many subjects will pose or even mug for the camera once they know you are taking their picture. This is not necessarily bad if a posed look is consistent with the image you seek, and many street photographers produce strong images this way. Nonetheless, achieving the appearance of a candid photograph can be difficult after one has obtained permission from someone not previously known. Although there are some ways to encourage subjects to return to a candid state after obtaining permission, asking a subject to look candid is rarely effective. However, waiting for the subject to relax

This approach takes a fair amount of bravado and is not for introverts.

or become distracted from the camera can help in getting good photographs.

Other street photographers feel that to ask permission is to lose the picture. One reason for not asking permission is that many situations develop quickly on the street and cannot be photographed if permission is sought beforehand. Similarly, it is often impractical to obtain permission—such as when photographing a public activity or people in crowds. Another reason for not asking permission is that many people will not act as they normally do once they know they are being photographed. Although it is legal to photograph in public places and photographers do not need permission, they may still respect peoples' feelings and refrain from photographing them in severe distress or embarrassing situations.

Although permission is not a legal requirement, this does not mean that street photographers do not face the potential for problems with regard to unauthorized photographs. People may object to being photographed and sometimes become confrontational. Verbally abusive responses are a possibility, as are reports to law enforcement officials. In extreme cases, subjects may demand the photographer's film or threaten physical violence. Confidence in knowing one's rights is important when photographing action on the streets but knowing how to avoid upsetting people can be more important.

Developing a style for taking candid street photographs should be done with due consideration for the methodology to be used. The extreme of the "no permission" approach is practiced by those photographers who hide their intentions by using tactics such as concealed equipment. Many people, photographers as well as the photographed, find this approach disturbing since it arouses suspicions and suggests that the photographer is acting illegally or with evil intent. In a few cases this approach may be justified if the photographer wants images of risky subjects such as people engaging in criminal activities. However, when the possibility of physical injury cannot be discounted many photographers find that discretion is the better part of valor.

The approach adopted by many street photographers is to conduct themselves so that they neither hide nor stand out. There is something about being bold and businesslike that tends to make people more comfortable because this behavior does not suggest improper or illicit behavior. By presetting focus and exposure, photographs can be taken quickly, often without the photographer being observed by the subject. In this regard, it is helpful to become well practiced with your equipment, which is why many street photographers use only

Many photographers find that discretion is the better part of valor.

Street photographers, while being conspicuous, can sometimes manage to blend in. I did not notice this photographer until about fifteen feet away.

one or two fixed focal length lenses. For the same reason, street photographers often use quiet equipment with fast film or lenses and avoid flash. When people notice that their picture has been taken, many street photographers advise that you should look friendly and avoid appearing defensive. Typical responses are to either smile at the person or to keep the camera at eye level and pretend you are photographing something else.

For most people, street photography takes a great deal of courage, and overcoming fear can be a big obstacle. Some photographers overcome their reticence about taking photographs of strangers by pretending they are not shy. It is important to avoid showing indecisiveness or fear. You can also distract yourself from your own fear by con-

centrating intently on a static element in a scene or the ground glass of a camera with a focusing screen. The environment can also influence courage. Crowded places such as busy urban sidewalks and public events such as parades can make photographing easier since people are either tuning out their environment or tend not to be as suspicious of photographers. People also tend to be more comfortable with photography at places such as amusement parks and fairs. In any case, experienced street photographers find that once they overcome the initial barrier of shyness, the entire process becomes much easier.

○ Photography from Your Property

The same property rights that allow others to restrict photography on their property give you the right to conduct it on yours. You are generally free to take photographs while standing on your property, even if the subject matter is located elsewhere. A notable exception that sometimes applies to commercial photography is when zoning and business laws prohibit operating a portrait or product studio in a residential neighborhood. However, even these regulations often provide for variances if few customers are expected to visit the property at any given time.

Although the doctrine of nuisance has seldom been applied to regulating photography, there is no legal reason why it cannot be used

Photography done on your own property will rarely constitute a nuisance irrespective of what the neighbors think. Boisterous and drunken astrophotography in the wee hours of the morning may be an exception.

to curtail photography that unreasonably affects nearby properties. A nuisance is legally defined as an activity that unreasonably interferes with another person's use of their property or a right common to the public affecting morals, comfort, or health. To be a nuisance, the activity must be of a kind that would cause an average person to suffer significant harm, discomfort, or offense. Activities that affect only hypersensitive persons are not nuisances. In addition, the gravity of the harm caused by the activity must be balanced against its social utility. Photography would generally be considered to have some degree of social utility unless it is done to intentionally annoy or injure someone. Quietly conducting astrophotography in your backyard would not constitute a nuisance even if the neighbors preferred that you were not outside with a camera at 2:00 A.M. Boisterous and drunken astrophotography at that hour would constitute a nuisance if it bothered those neighbors who chose not to participate. From a practical perspective, most situations involving photography will constitute a nuisance only because the ancillary activity offends or annoys others. For example, photographing squirrels in your front yard would not be deemed a nuisance even if your hypersensitive animal-rights activist neighbor is appalled by the stress it might induce. On the other hand, photographing unclothed models in the same setting could be construed as a nuisance if the neighbors are offended by public nudity.

If you are faced with a situation where photography may cause a nuisance, attempting to minimize the annoyance or disruptions experienced by others will work to your legal benefit since courts consider efforts at mitigation when determining whether a particular activity constitutes a nuisance. Efforts to limit photography to reasonable hours or otherwise minimizing the annoyance to others can tip the balance from gravity of harm to social utility. In such cases, a little sensitivity to neighbors and reasonable efforts at accommodation can prevent disputes altogether.

> Conducting astrophotography in your backyard would not constitute a nuisance.

Privacy Issues

ALTHOUGH THE LAW OF PROPERTY RIGHTS governs where you can take photographs, laws that protect personal privacy affect the circumstances in which you may photograph people. The underpinning for privacy law in the United States is the right to be left alone, but in most cases the protection is rather limited. Nonetheless, photographers need to be aware of when they can photograph people and when they are legally required to refrain. They also need to understand the role of consent in reducing their exposure to liability and how best to document it.

O Intrusions on Privacy

Despite the importance that society places on personal privacy, the law imposes relatively few restrictions on photographing people. Even the most sensitive aspects of people's lives, including extreme tragedy and embarrassing moments, may be photographed freely unless the subjects have secluded themselves in a place or manner where they can reasonably expect privacy. Much confusion over the right to photograph people comes from failing to distinguish between the legal aspects of taking photographs and those of publishing them. The laws that protect against unauthorized publication are much broader than those that apply to taking photographs. For example, you would not violate a celebrity's legal right to privacy by photographing him walking in public view, but would violate his rights if you used the photograph to illustrate an advertisement without his permission.

The privacy right that is most relevant to the taking of photographs is called the tort of intrusion upon seclusion. This is a fairly limited right that allows people to recover damages when someone intentionally intrudes on their seclusion or private affairs in a way that an ordinary person would find highly offensive. Photography is but

> **Photographers need to be aware of when they can photograph people . . .**

one of many ways in which this privacy right may be violated; others include opening private mail, viewing financial records, and wiretapping. You can usually take a photograph of someone in a public place irrespective of whether it concerns a matter the subject, or even most members of the public, would prefer not to have recorded. For example, courts have held that photographs of a couple caressing at a public market, a fan standing up at a football game with an open zipper, and postal employees standing next to a senator at their workplace did not constitute actionable invasions of privacy. Even though the subjects resented the photography of what they considered to be personal moments, embarrassing situations, or unwanted implied associations, the photographs were taken in public places and thus did not involve the kind of private facts encompassed by the tort of intrusion. Courts have also held that photographers may stand in places open to the public and record the interior spaces of businesses without incurring liability under the intrusion tort. However, intentionally viewing and photographing people inside of residences is generally an actionable invasion of privacy absent their permission.

One exception to the right to photograph people in public view is that one cannot photograph something that the person has a reasonable expectation of keeping private, even when the person is in a pub-

Photographing the interiors of businesses that are open to the public view is not an invasion of privacy.

photography can violate the privacy rights of inmates who do not consent to being photographed while they are in parts of prisons or jails that are generally secluded from the view of outsiders.

The tort of intentional infliction of emotional distress requires conduct that one knows will be so severe that a reasonable person cannot be expected to endure it.

○ **Intentional Infliction of Emotional Distress**

Although the law allows for most photography in public places regardless of its emotional effect on others, photographers can be liable if they actually intend to cause their subjects to suffer emotional distress. This kind of claim is most commonly called the tort of intentional infliction of emotional distress or outrageous conduct. To be liable a person must act intentionally or recklessly in a way that

exceeds the bounds of public decency and that causes someone to suffer emotional distress so severe that a reasonable person would not be expected to bear it. A great deal of rudeness or inappropriate behavior is required before a claim for outrageous conduct can be expected to succeed. Not only must a plaintiff prove that the conduct was intended to cause emotional distress, he or she must show that the emotional distress was severe. Insults, annoyance, and indignities are not sufficient to support a claim.

The case of *Muratore v. M/S Scotia Prince* is a good illustration of how photographers can be held liable for boorish and unnecessary behavior. The plaintiff was a passenger on a cruise ship sailing from Maine to Nova Scotia. The voyage started off ominously when the two photographers working for the cruise line refused to honor the plaintiff's request that she not be photographed. The photographers took pictures anyway and posted one after doctoring it by pasting a gorilla's head over her head. The photographers continued to take pictures of her throughout the cruise despite her objections. During one confrontation, one photographer told the other to "Take the back of her—she likes things from the back," which the plaintiff (and later the court) construed to be highly offensive. Needless to say, being harassed and embarrassed over being photographed made for an unpleasant trip. During much of the cruise, the plaintiff stayed in her cabin to avoid the photographers. After the cruise, she filed a lawsuit alleging that the photographers invaded her privacy and intentionally inflicted emotional distress. The court ruled against her on the invasion of privacy claim, noting that all the photography took place in the public areas of the ship. However, the court ruled in her favor on the outrageous conduct claim, finding that the photographers had deliberately tried to upset the plaintiff by playing on her sensitivity about being photographed.

The *Muratore* case stands as a good lesson regarding the importance of mature and respectful conduct when taking photographs. The photographers were supposedly employed on the Scotia Prince to provide a service to the passengers and not to harass them. Any reasonable person could have deduced that neither the plaintiff nor other passengers were likely to purchase photographs of the plaintiff and that there was little if any business justification to take them. More mature photographers could have easily avoided liability by honoring the plaintiff's wishes—or at the very least by not insulting her. Showing courtesy and respect to subjects can be extraordinarily effective way to avoid liability for outrageous conduct since hard feelings often provide a stronger motive to pursue legal claims than the prospect of monetary compensation.

Being harassed and embarrassed made for an unpleasant trip.

○ Regulation of Photography to Protect Privacy

Although the common law doctrines play the dominant role with respect to privacy issues, many states have enacted statutes that limit the intrusion of photography into personal privacy. While most of these laws mirror the common law elements by prohibiting photography of people in private places without their consent, they differ in that violations constitute crimes that can result in fines or even incarceration.

One kind of privacy statute generally prohibits people from looking into dwellings with the intent to interfere with privacy. Although

When photographing residential structures, one should be careful not to inadvertently record the private activities of the occupants.

these ordinances would not apply to inadvertent glances through windows and doors, they do make taking photographs of private activities in dwellings unlawful. Examples of the types of dwelling units covered by these laws are houses, apartments, hotel rooms, and motor homes. These laws can be interpreted to protect any activity within the confines of a residential structure and arguably extend liability beyond what is encompassed by the tort of intrusion.

Some states have enacted laws that specifically prohibit installing or using devices to photograph people in a private place without their consent. These statutes vary widely in their specificity. For instance, some legislatures prefer general language such as contained in a New Hampshire statute that defines a private place to be "a place where one may reasonably expect to be safe from surveillance but does not include a place to which the public or a substantial group thereof has access." Other legislatures make their statutes more specific, such as the Oregon statute that expands the definition of private place to include "a bathroom, dressing room, locker room that includes an area for dressing or showering, tanning booth and any area where a person undresses in an enclosed space that is not open to public view." Such specificity can be helpful in defining the limits of lawful conduct. For example, one can discern with certainty that a locker room associated with a community swimming pool qualifies as a private place in Oregon whereas the legal status of such areas in New Hampshire is more open to interpretation.

State privacy statutes also vary with respect to the activities they protect. For instance, the New Hampshire statute applies to any activity occurring in a private place while the Oregon statute applies only to persons in a state of nudity. California has enacted a statute intended to protect the privacy of persons engaged in personal or family activities. This statute makes it a tort to physically trespass onto the land of another in order to make a visual image or sound recording of persons who are engaged in personal or family activities if the trespass occurs in a way that would offend a reasonable person. One can also be liable under the statute for a constructive invasion of privacy if the image or recording is made with a visual or auditory enhancing device, irrespective of whether there is a trespass if the image or recording could not have been made without the device. In theory, photographers in California could be liable for taking photographs with telephoto lenses or night vision devices. If found liable under the statute, defendants can be required to pay plaintiffs up to three times the damages suffered and also to disgorge any profit made from the image or recording. Although this law applies to all persons within California, the primary motive behind its passage was

> State privacy statutes vary with respect to the activities they protect.

to provide more privacy to celebrities. This law has been criticized both for its vagueness and its potential to hinder news coverage.

Another potential source of liability for photographers who follow or repeatedly photograph particular subjects are stalking statutes, although they are generally enforced in contexts that do not involve photography. Many states have passed such statutes, which make it a crime to repeatedly engage in activities such as following, surveillance, and harassment with an intent to either harm a person or cause a material level of fear or emotional distress. The act of photography, by itself, is unlikely to violate a stalking statute. Nonetheless, furtive or persistent behavior that alarms a subject could result in being reported to the police for investigation. Some stalking statutes could be construed to make it a crime to persist in taking photographs of a person for no legitimate purpose after being asked to stop.

○ Security Monitoring

Security monitoring is widely used to deter crime and protect patrons and employees at commercial establishments such as banks and office buildings. Irrespective of how people feel about security monitoring, anyone may legally set up a camera to monitor areas in public view. Security monitoring is rarely resented when it makes people feel safer, and reasonable applications will not result in claims. However, when security monitoring extends into areas where people legitimately expect privacy the chances of incurring legal liability greatly increase.

A particularly sensitive issue is the monitoring of dressing rooms at retail establishments to detect shoplifters. Most retailers who sell clothing make dressing rooms available to customers to try on clothing before deciding whether to make a purchase. Since the purpose of these rooms is to shield partially dressed customers from public view, retailers in effect are creating an atmosphere where privacy is expected. Unfortunately, some retailers have resorted to surveillance monitoring to detect shoplifters who use dressing rooms to conceal merchandise. Some, but not all courts have shown considerable tolerance to this practice although most of the decided cases have involved prosecutions of accused shoplifters. For instance, appellate decisions in several states have held that the posting of warnings that such facilities were under surveillance by store personnel constituted consent on the part of customers who chose to use them. Some courts have also held that openings in or around doors and curtains reduce the expectation of privacy that patrons may have. This does not mean that courts necessarily favor the monitoring of dressing rooms; in fact, some have awarded damages to the innocent victims of such surveillance. Furthermore, as other technologies to deter

This does not mean that courts necessarily favor the monitoring of dressing rooms.

shoplifting become more available, judicial acquiescence of such monitoring should decrease. In addition, some states have statutes that prohibit viewing or photographing anyone without their consent in dressing rooms.

Restrooms are another area where surveillance presents legal problems. The most common reason for using surveillance is to deter drug transactions, sexual activity, and vandalism. Whether surveillance in a restroom will invade a right to privacy depends on the circumstances. Although there is no general expectation of privacy in the common or open areas of restrooms, many courts have held that intentional surveillance of toilet stalls is a privacy invasion.

Security monitoring in places such as the public areas of banks is rarely resented since it deters crime and makes patrons and employees feel more secure.

Surveillance of somewhat exposed areas such as urinals may also invade privacy depending on factors such as camera location and angle. Courts are less likely to protect privacy within toilet stalls when the circumstances indicate the stall is not being used for its normal purpose. Examples of such conduct are the presence of two or more people in a stall, spending an inordinate amount of time in the stall, and making noises consistent with illicit drug use. Although cases involving the surveillance of restrooms have varied results, courts tend to rule in favor of innocent parties even when they were photographed by parties who only intended to curtail improper activities.

Courts tend to rule in favor of innocent parties.

O Photography in the Workplace

As a general rule, employers are free to photograph employees in most areas of the workplace since they are not in seclusion. Employers may also require that employees submit to being photographed for the purposes of identification and work-related activities such as time-motion studies. Nonetheless, resentment against monitoring can make workplace photography a sensitive legal area.

Employers who want to minimize the prospect of being sued and reduce employee objections about workplace monitoring should implement it as part of a carefully considered program. An important issue to address in developing a program is to ascertain that the monitoring addresses legitimate business purposes and does not unduly intrude on the affairs of employees. It is likewise important to clearly define the limits of what can be monitored to avoid abusive or unnecessary practices that are likely to result in lawsuits.

Excessive or abusive monitoring can violate employee protection laws. For example, monitoring of restrooms and dressing areas could lead to the creation of a hostile work environment and constitute sexual harassment. In some cases, business concerns can be addressed effectively by finding an alternative to visual monitoring. Employers who use workplace surveillance can often reduce employee objections by explaining the scope and purpose of the monitoring to their employees.

Employers sometimes resort to secret or concealed photography to monitor employees who are suspected of improper activities. Such monitoring is usually lawful so long as the employer avoids monitoring intensely private activities. One exception is that monitoring to identify employees who may be informing the government about violations of defense contracts or environmental laws could violate whistleblower laws.

Another exception to the rule that employees may generally be photographed by employers applies to union activities such as picketing, accepting handbills, and attending union meetings. Under the National Labor Relations Act, employees have the right to engage in concerted action for collective bargaining and mutual aid or protection. Any action by an employer that coerces employees from participating in concerted actions is an unfair labor practice and thus unlawful. The National Labor Relations Board has issued several decisions holding employers liable for having initiated photography of union activities because it might have intimidated

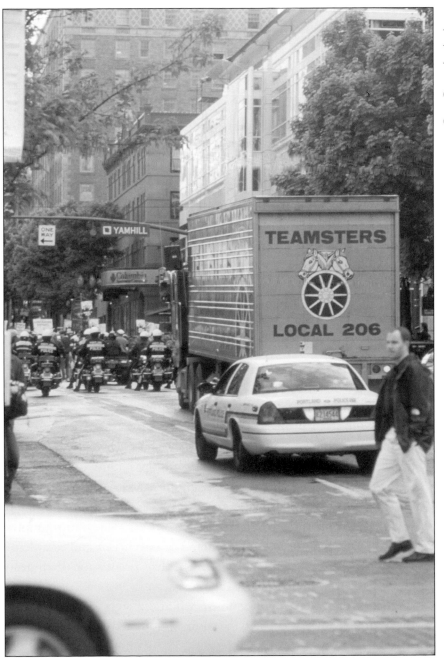

Employees have the right to engage in concerted action.

While most people are free to photograph union activities, employers cannot if doing so might intimidate employees from participating in concerted action.

employees. In a few cases, courts and the board ruled that photography is lawful when done solely to record evidence of unlawful acts by employees. Employers who want more latitude to photograph union employees may want to address such issues in their collective bargaining agreements.

Employees may generally presume they can take photographs in their workplace unless the employer has explicitly prohibited photography or where it could damage the employer's interests such as by disclosing trade secrets. Legally, employees owe a duty to avoid acting contrary to the best interests of their employers while they are on the payroll. This means that employees cannot take photographs that may harm the employer except in the special case when such activities are covered by laws that protect employee disclosures to government agencies such as whistleblower statutes.

○ The Role of Permission in Photography

The best way to protect oneself from being sued for invading someone's privacy is to obtain his or her consent to be photographed. A person can consent to be photographed by implication or expressly in speech or writing. Written consent provides the best legal protection since it provides a permanent record that permission was given. Although implied and oral consent are, in theory, as effective as written consent, the practical difficulties of proving them in court make them less desirable. For instance, reliance on implied or oral consent means the photographer is vulnerable to having the subject either forget or lie about giving permission.

It is a good idea to get a release even when permission is not legally required to take a photograph. One reason is that most advertisers and some publishers require releases before they will purchase the rights to use photographs of identifiable persons. Without releases, it can be difficult to market some kinds of photographs. Even when there is no intent to profit from an image, releases may be warranted when the circumstances give the appearance that the subject's privacy rights may have been violated. For example, taking a photograph of an exterior window that frames a couple caressing inside a bedroom could give the impression that the photographer has violated laws against voyeurism. Absent a written release, the photographer could face a difficult situation if accused of voyeurism and unable to locate the models who can corroborate that permission had been given.

Implied consent may be assumed when subjects know they are being photographed and their reactions would be understood by a reasonable person to indicate consent. For example, when people

The photographer could face a difficult situation if accused of voyeurism.

apparently welcome being photographed or do not appear to object, one may assume they have consented. However, implied consent to be photographed will not necessarily be construed as consent to publication unless the subject has reason to believe that the photographer intends to have the work published. In one case, a man sued the publisher of *Sports Illustrated* after it took and published a photograph of him standing up at a football game with his pants unzipped. The court, in addition to noting that the photograph was taken in a public place and was newsworthy, held that the fan had given implied consent since he was aware that the photographer was working for *Sports Illustrated* and was seated among a group of fans that had asked to be photographed.

For consent to be effective, it must be granted by someone who is capable of understanding the nature and consequences associated with the photography and who has the authority to give the consent. When photographing mentally competent adults, it is usually necessary to get permission from the person actually being photographed. For example, people cannot consent on behalf of their spouses to allow them to be photographed surreptitiously in private activities. The possible exception is when the subject has clearly given someone else the authority to consent on his or her behalf such as might be the case for a publicist working for a celebrity. When photographing minors and persons suffering significant mental disabilities, you need to get permission from an appropriate party such as a parent or guardian.

Consent obtained through misrepresentation is invalid if the subject misunderstands the nature of what is being photographed or how the photographs may be used. For example, someone who agrees to model without clothes after being told the photographs will be used to illustrate a medical text would likely have a cause of action should the photographs be marketed as posters. However, consent that is based on the photographer representing a subjective opinion will be effective even if the subject's opinion ultimately differs. For example, models who are assured that they will be portrayed attractively or artistically cannot argue that their consent is invalid merely because the photographs fail to meet their personal expectations.

The standard document that most photographers use to record written consent is the model release. At a bare minimum, the release should state that the model has agreed to be photographed and has given permission for the photographs to be published. Many releases, including most of those available as preprinted forms, address more issues but do not necessarily provide better legal protection to

> Get permission from the person actually being photographed.

the photographer. As noted previously, consent is ineffective if the subject misunderstands the nature of what is being photographed and the intended scope of use. In addition, courts sometimes refuse to enforce provisions they consider unconscionable. Using complex release forms that express simple concepts in obtuse legal terms increases the chances that a court will find that the subject misunderstood the scope of their consent. In such cases, a court may rule the consent is ineffective.

To better understand how releases work, it is helpful to evaluate the most common clauses and their legal effect. All model releases identify the subject who is granting consent and provide for his or her signature (or one from a parent or guardian). Surprisingly, since the scope of consent is a critical legal issue, few preprinted release forms provide spaces for identifying the general subject matter or the dates on which the photographs are taken. Nonetheless, it is a good idea to describe the general nature of the photographs and the period in which they were taken on the release before it is signed. By doing so, photographers can avoid disputes over what the release was intended to cover.

Many model release forms recite that the subject has received *consideration*. Consideration is the legal term for payment for property, services, or the surrender of a legal right. In my opinion such recitals are usually unnecessary in a release and may even be counterproductive. When the primary purpose of the release is to protect the photographer and subsequent users of the photographs from claims that privacy rights have been violated, all the release needs to do is to document that the subject has given permission to be photographed and for subsequent publication. There is no need for a release to constitute a contract to be effective. Since the concept of consideration relates to contract law, releases that contain consideration clauses can create doubt regarding whether the consent is a condition of the contract or is an independent statement. Since consent by itself is sufficient to negate a claim that a model's privacy rights have been violated, adding a consideration clause to a release can weaken the legal protection because a court could find the consent invalid if for some reason it finds the contract to be unenforceable.

Consideration clauses can be particularly problematic when the photographer does not actually pay the subject. Not only does the failure to pay create an issue regarding whether the release fails without an actual payment, it may open the door to claims that the subject is owed money. Courts traditionally have been hostile to enforcing contracts when the nominal nature of the consideration indicates that it was a mere formality and not the result of a bargained

There is no need for a release to constitute a contract to be effective.

transaction. In addition, most courts will disregard recitals in which the subject acknowledges receiving consideration and allow evidence to be admitted regarding whether payment was actually made. If the release form fails to quantify the consideration, the photographer may face claims that a lot of money is owed to the model.

One useful purpose consideration clauses can serve is to preclude models from revoking their consent in the future. Without a binding contract, parties are free to revoke their consent and thus prevent subsequent publication of the images. If the consent is in fact a condition of the contract, the photographer should ensure this is clearly expressed. The best way to do this is to use separate contract and release forms in which the contract form requires the model to sign the release. In addition, the consideration should be commensurate with the services rendered. The amount paid does not necessarily have to be great but it should be more than a mere token. Photographers who do not pay their subjects will probably be better off forgoing the use of consideration clauses since the practical aspects of revoking consent reduce the potential for hardship. For one thing, a revocation is not effective until it has been expressed to the parties protected by the release. In many cases, models will not know how to contact the photographer and thus will be unable to effect a revocation until after the photographs are published. Also, courts typically allow those who rely on another's consent to act in a reasonable manner to protect their interests. This means that it is unlikely that a court would prevent a publisher from selling books with photographs of a particular model if the consent was revoked after publication. In fact, a court might rule that a model is barred from revoking consent altogether provided the release clearly communicated the prospect of future publication at the time the photograph was taken.

Many release forms contain recitals that describe the potential ways the photographs could be used, although they are usually written in verbose and legally bloated text. A release is sufficient if it documents the model's consent that the photographs may be published for any purpose, including advertising and promotions. Although there is some merit to addressing issues such as altering photographs or the use of accompanying text, photographers should be careful not to impair the ability of the subject to comprehend a release form by making it too complex. Also, introducing too much specific language opens the door to a court ruling that the specific nature of the release implies that matters not specifically described are beyond its scope. For example, a court could decide that a release that allows a photograph to be used in any "book, journal, magazine, pamphlet, news-

Without a binding contract, parties are free to revoke their consent . . .

paper, or other printed document" does not extend to fine art prints or publication on the Internet because these uses were not described in the specific text used in the release. Conversely, a court would likely find that fine art prints and Internet use were adequately described in straightforward text such as "published in any form and for any purpose."

One exception to using general text to describe how photographs might be published may apply when the photographer knows that an image is likely to be used in a sensitive or controversial context. For example, a general release signed by the mother of a teenage girl may be acceptable when a photographer is taking photographs for general stock use but would be less prudent if the photographer is on assignment to illustrate an article about teen drug abuse. In such cases, photographers are better off legally if they explain how the photograph will likely be used and document the model's consent to that particular use.

Releases are often cluttered with irrelevant provisions that do nothing to alter the legal rights of photographers or subjects. For example, releases sometimes state that the subject warrants having the capacity to sign the release. The problem with such clauses is that people who lack the capacity to consent also lack the capacity to warrant they have the capacity to consent. Clauses that state the subject acknowledges reading the release prior to signing it are similarly illogical since subjects who do not read the release cannot knowingly acknowledge having done so. Although these kinds of clauses probably won't hurt the photographer, they provide little practical protection and are better omitted for the sake of clarity.

Photographers can also make their releases clearer by omitting provisions that merely document the legal rights the photographer and subject have anyway. For example, permission from a model is never needed to copyright a photograph and such recitals in releases are unnecessary. Similarly, consenting to be photographed cannot be construed to transfer the copyright to the subject since such transfers must be expressed in writing. In short, copyright clauses are unnecessary in releases.

Photographers should also be careful to avoid releases that contain clauses that are invalid because they are unconscionable. While courts give considerable leeway in allowing the parties to negotiate the extent of a release, they will not enforce provisions that are so one-sided as to shock the conscience. One type of unconscionable provision commonly found in release forms is the indemnity clause. These clauses are usually drafted with terms such as "indemnify," "hold harmless," or "save harmless" and purport to require the model to

pay or reimburse the photographer for any legal expenses and damages suffered should the photographer be sued because of the photograph. Such terms are clearly overreaching and courts will not enforce them. In fact, they present some degree of risk to photographers in that a court may be sufficiently offended by the overreaching clauses to rule that the entire release is invalid.

Using a Simple Release Form. When reviewing a release to determine whether it records an effective consent, courts will consider the clarity of the text, the sophistication of the subject, and the overall fairness of the agreement if the release purports to be a contract. In such cases, a complex release form may work against the photographer. Because they are easier to understand, simple releases are more ethical and in my opinion better protect the photographer than lengthy and complex releases. Another advantage of simple release forms is that they can be printed on small pieces of paper while still maintaining a legible type size. This allows photographers to carry them in convenient places such as wallets or even attached to photographic equipment.

An example of a simple form is presented on the following page.

Some models may wish to limit the scope of their consent. For instance, they may object to using the photographs to advertise products they find objectionable. When this occurs the photographer can avoid having to draft an entirely new release incorporating the model's restrictions by writing in the limitations at the bottom of the standard release form and having them initialed by the model and the photographer to confirm the revision.

When photographing minors or other persons who lack the legal capacity to consent, the release can be altered to indicate that a parent or guardian is signing on the model's behalf. Alternatively, a form such as the one on the following page can be used.

> **A complex release form may work against the photographer.**

Sample Forms

Consent to Be Photographed and Published

I, _____, consent to be photographed on [insert dates] by [name of photographer] while [describe context or subject matter]. I further authorize that the photographs may be published for any purpose and in any form.

_____ _____
Signature Date

Parental or Guardian's
Consent to Be Photographed and Published

I, _____, as parent or legal guardian, authorize [name of photographer] to photograph [name of model] on [insert dates] while [describe context or subject matter]. I further authorize that the photographs may be published for any purpose and in any form.

_____ _____
Signature Date

4

Restrictions on Subject Matter

WHILE FEW SUBJECTS CANNOT BE LEGALLY PHOTOGRAPHED, much confusion and many misconceptions abound. Nonetheless, it is important to understand the legal limits of what may be photographed since the sanctions for violating these laws are often severe. Knowing the law regarding subject matter restrictions can also keep you from being misled by people who misunderstand what can and cannot be legally photographed.

○ Federal Statutory Restrictions

Several federal statutes prohibit the photography of certain subjects except when authorized by a designated official or by regulation. Some of these statutes promote a significant government interest such as preventing counterfeiting while others border on the absurd, such as criminalizing the commercial appropriation of the Woodsy Owl character. These laws are typically vague, spottily enforced, and difficult to find. In many cases, Congress has drafted the controlling statutes so broadly that it can be difficult to determine the boundary between lawful and unlawful conduct. The government often justifies this approach to regulation by arguing that it needs the flexibility to enforce against conduct that was not contemplated during the legislative process. It likewise claims that the harshness of unclear laws can be alleviated by not enforcing them when it would be unjust to do so. Unfortunately, relying on the graciousness and good sense of the government provides little comfort to photographers who need to know where the line is between lawful and unlawful conduct.

Restrictions based on how the photographs will be used are disfavored from a constitutional perspective since the First Amendment limits the power of the government to restrict expression based on its content. Some federal statutes and regulations purport to limit photography of some subjects to particular purposes, such as education

> Several federal statutes prohibit the photography of certain subjects.

or news coverage, and a few prohibit photography that may demean a symbol or a particular agency. Although there is an extensive body of law regarding the government's ability to regulate expression, few cases have interpreted the statutes and regulations that restrict photography based on subject matter. This further aggravates the already difficult problem of determining whether and how a particular law applies to a photographer's activities. When faced with a situation where the plain language of a statute or regulation prohibits what appears to be constitutionally protected expression, it is wise to consult with counsel before proceeding with what may or may not be lawful photography.

The government's power to regulate what may be photographed depends on whether it has a legitimate interest in restricting some forms of expression. Although courts have found many social objectives to be compelling, they tend to be suspicious of restrictions that are based on the content of the expression and give them more scrutiny than restrictions on the time and manner of expression. Political expression, particularly that which criticizes the government, is subject to the highest level of scrutiny and the government has a high burden to establish that its interest in restricting such expression is in fact compelling. The evaluation of restrictions on photography that is to be used for news, art, and educational purposes likewise receives a heightened level of scrutiny. Commercial speech, such as advertising, is subject to a much lower level of scrutiny. This means that the government has considerably more latitude to restrict photography used to promote commercial interests than it does when it is used for political or news purposes. For example, one federal court ruled that the U.S. Forest Service can restrict the reproduction of the Smokey Bear character for commercial purposes but not when used to illustrate political criticism.

Constitutional issues aside, a few federal statutes and several regulations that regulate the photography of certain subjects require government officials to either specifically authorize what may be photographed or to promulgate regulations that define the restrictions on photography. This presents photographers with a practical problem when the government fails to respond to requests for permission to photograph something or fails to promulgate the required regulations. The most common reason offered by government officials for ignoring requests or not drafting rules is a lack of resources, but in many cases the real reason is there is little interest to do so. Since few cases warrant the expense or effort needed to file a lawsuit demanding government action, the vacuum caused by agencies failing to follow statutory mandates can be expected to persist. As a practical mat-

Political expression is subject to the highest level of scrutiny.

ter, photographers who face situations where permission is required should submit their requests as early as possible and be prepared to follow up zealously if necessary.

O Currency, Stamps, and Securities

Concerns over photography as a counterfeiting tool have been addressed by federal statutes that substantially restrict the ways currency, postage stamps, and securities can be illustrated. The use of photography to make illustrations was formerly limited to historical, educational, newsworthy, and collector purposes, but such restrictions have been removed in amendments to the anticounterfeiting statutes. Most of the litigation over these laws has involved actual counterfeiting operations, but photography for any purpose is regulated. Since few cases have interpreted these statutes outside the context of counterfeiting, the law is not entirely clear as to what constitutes a regulated illustration. For instance, the U.S. Supreme Court has held that a magazine violated these statutes by incorporating images of currency in a graphic that illustrated a sports article because the images did not meet the statutory guidelines for reproductions of currency despite the minimal utility such illustrations would have to counterfeiters. However, instead of confronting the issue of whether

The federal government has never clearly stated how statutes intended to prevent counterfeiting apply to incidental and de minimis depictions of currency in photographs.

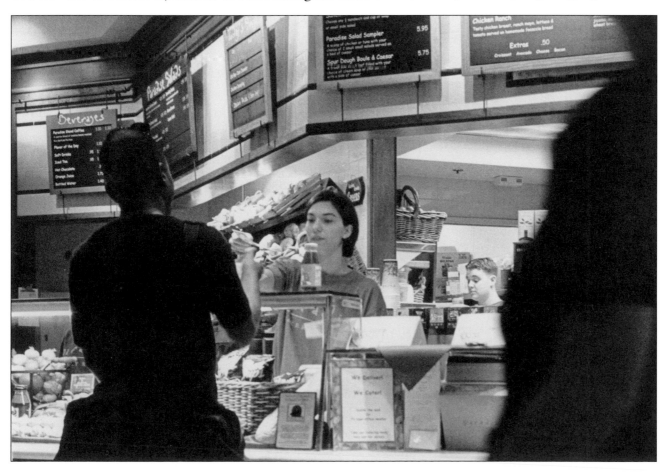

images that incidentally include currency violate the anticounterfeiting statutes, it merely commented that it had no evidence that the government has or would ever interpret these laws to encompass incidental depictions. This means that photographers cannot be assured that these statutes cannot be enforced to their illogical extremes.

The government has issued guidelines that describe what images may be made without violating the law. To comply with these guidelines, illustrations of U.S. currency must be in black and white except when less than three-fourths or greater than one and one-half the actual size of the item illustrated. Photographs of other U.S. obligations such as bonds and of foreign currencies can only be reproduced in black and white and must also be less than three-fourths or greater than one and one-half the actual size of the item. All illustrations of currency must be one-sided. Coins may be freely photographed for any nonfraudulent purpose. Postage stamps may be illustrated in either color or black and white and in any size if they have been canceled. Uncancelled stamps can be reproduced in black and white in any size but if reproduced in color must be less than three-fourths or greater than one and one-half the size of the actual stamp. Postage meter stamps are considered postage stamps under this law. Illustrations of revenue stamps can only be reproduced in black and white. Another requirement regarding photographs used to illustrate currency and stamps is that the negatives, plates, or other storage media must be destroyed after their final use. In addition, while it is lawful to make motion pictures, videos, and slides of currency so long as the purpose is for projection or telecasting, no prints can be made from these unless they conform to the size and color restrictions described above.

Photographing any currency, stamp, or security obligation to facilitate counterfeiting or forgery is a separate federal crime and is also illegal under many state laws. These laws apply more broadly than the restrictions regarding how currency and stamps may be illustrated. For example, the term *security obligation* encompasses stock certificates, corporate bonds, certificate of deposits, checks, money orders, bills of lading, and automobile titles. Unlike the laws governing illustrations, the government cannot convict someone for photographing obligations issued by private persons or organizations unless it first proves that the photographer intended to use the images to make counterfeit or forged documents.

○ **Federal Insignia, Seals, and Trademarks**

Congress has enacted several statutes that limit the reproduction of agency insignia, military decorations, and some trademarks. These

Coins may be freely photographed for any nonfraudulent purpose.

statutes appear to promote three kinds of federal interests. The first is to prevent unauthorized persons from using agency insignia and identification to falsely convey that their activities are sanctioned by the U.S. Government. The second is to establish government control over the commercial use of these items. The third interest is to prevent private citizens from using federal marks and insignia in ways that demean or offend the U.S. Government. Courts would undoubtedly uphold the power of the government to regulate the reproduction of these items for fraudulent or commercial uses but the constitutionality of preventing their use to express political opinion is highly questionable.

Although the federal statutes regarding seals and insignia address commercial appropriation and deceptive practices issues, they often fail to address photography in other contexts such as news, art, and personal use. This is unfortunate since drafting statutes in a way that protects the legitimate government interests yet avoids overbroad restrictions is not that difficult. For example, the statute that prohibits reproducing the Golden Eagle insignia (the symbol of federal recreational fee areas) is written to clearly state that as long as people do not intend to use a reproduction of the insignia for some kind of fraudulent purpose, they are free to photograph it. Unfortunately, most statutes that regulate the photography of government symbols are overbroad because, while they are apparently intended to prevent deceptive uses, they could theoretically be construed to prohibit any photography of symbols that has not been authorized by regulation or a senior official.

One such federal statute could be interpreted to make it unlawful to make images of the seals of the United States president, vice-president, Senate, or House of Representatives except as authorized by regulations. Although the statute seems intended to limit commercial uses of these seals, a literal interpretation would prohibit taking photographs of politicians standing next to presidential and congressional seals unless properly authorized. The government has provided little guidance regarding when these seals may be included in photographs although an executive order does make it lawful to photograph the presidential and vice-presidential seals for bona fide news or educational purposes without prior permission. In other cases involving exceptional historical, educational, or newsworthy purposes, permission to reproduce the seals may be obtained in writing from the Counsel to the President or the clerks of the Senate and House of Representatives.

Federal law also restricts the photography of agency insignia without authorization. The general statute that governs the reproduction

Federal law also restricts the photography of agency insignia without authorization.

and use of most agency insignia provides that whoever photographs an insignia, badge, identification cards, or tolerable imitations thereof except as authorized by regulations is guilty of a misdemeanor. Since most agencies have not promulgated regulations that authorize the photography of their insignia, the legal aspects of photographing them are not entirely clear. Furthermore, the few regulations that have been promulgated tend not to address issues concerning general photography. For example, the U.S. Forest Service restricts the use of its insignia to official use except when specifically authorized for public service or commercial uses that contribute to the public recognition of the forest service. Although its regulations do not prohibit photography of the insignia for news, educational, or personal use, they fail to explicitly authorize it.

Similar statutes encompass the reproduction of military decorations and badges and medals of veterans' organizations incorporated by act of Congress. For example, the Department of the Army authorizes the photographic reproduction of insignia so long as no discredit is brought on the military and the reproductions are not used for deceptive purposes. While the Army certainly has the power to prohibit reproductions for deceptive purposes, its authority to restrict on the basis of whether the use portrays the government favorably or unfavorably is constitutionally suspect.

While it is generally lawful to photograph private trademarks, the federal government has the power to increase the legal protection associated with government trademarks and has done just this with respect to the Smokey Bear and Woodsy Owl characters. The two statutes that protect these marks prohibit anyone from reproducing them for profit except as authorized by the U.S. Department of Agriculture. In addition, a third statute gives the Attorney General the authority to enjoin any reproduction of Smokey Bear or Woodsy Owl irrespective of how the image is used unless such use has been authorized by the U.S. Forest Service. At least one court has ruled that these statutes would not apply to photography done for noncommercial purposes. This means that citizens may photograph Smokey Bear and his likeness without fear of prosecution so long as the photographs are used for editorial or personal purposes.

◯ Military and Nuclear Installations

Two types of laws regulate the photography of defense-related materials, equipment and installations. Espionage laws prohibit anyone from gathering information respecting the national defense who knows or should know that the information will be used in a way that injures the United States or benefits a foreign government. Another

These statutes would not apply to photography done for noncommercial purposes.

Despite the government's interest in preserving the value of the Smokey Bear character to the campaign against forest fires, it cannot prohibit unauthorized photography for editorial or personal purposes.

set of laws prohibits the unauthorized photography of military installations and equipment that have been classified as top secret, secret, confidential, or restricted, irrespective of whether the photographer intends to disclose information to foreign governments.

Photographers who work around defense and intelligence facilities should be aware that the laws against espionage reach beyond classic spying. The mere act of taking photographs that depict national security material can expose photographers to criminal liability if they know they will be disseminated by the media. Absent special access to sensitive facilities, photographers are unlikely to violate these laws but government and contractor employees should be careful not to pho-

Restrictions on photography are not limited to military installations.

tograph sensitive materials if unauthorized persons are likely to view the images.

The laws against photographing classified equipment and facilities do not require any intent to harm the United States and are easier to enforce than the laws against espionage. They require photographers to obtain permission from the commanding officer of a facility or a higher authority before photographing classified materials and to agree to submit their images for censorship. In general, areas that have been designated as classified are not readily visible outside of military installations so this is usually not an issue with respect to photography done from outside the installation except for aerial photography. When photography is done on a military installation, permission should be sought except when the circumstances make it clear that photography is not restricted. For example, it would be a good idea to seek permission to photograph inside an aircraft maintenance shop but permission would not be needed to photograph a sporting event at a school located on the installation. Most facilities have a public information officer who should be familiar with the issues associated with photography on the installation. Consulting with this person can help avoid problems and confrontations when photographing at a defense facility.

Restrictions on photography are not limited to military installations. Federal law authorizes the military to regulate photography at sensitive defense manufacturing and research facilities. Military authorities can also restrict photography of experimental equipment and aircraft and also at crash sites, if necessary, to prevent the disclosure of classified information. In such cases, however, regulations require the military to seek the assistance of civilian authorities to actually seize equipment. Note that these restrictions do not apply once the classified material has been covered or removed from the scene.

The photography of nuclear facilities that have been designated by the government as requiring protection from general dissemination of information is prohibited unless previously authorized by the U.S. Department of Energy. These requirements apply to photography that occurs either on designated property administered by the U.S. Department of Energy or from the air. Photographing nuclear facilities from outside their property lines is permissible.

One problem when photographing defense or nuclear subjects is that the degree of zeal with which these laws are enforced varies greatly. Part of the difficulty is that security personnel have different priorities and perspectives with regard to photography. Some tend to be very protective, some are lax, and there are quite a few that enjoy

asserting their perceived authority. In some instances attitudes within the services may conflict. For instance, a high-level official at the Pentagon may spend hours arranging access for film producers in order to gain positive publicity for the military services while low-level security staff may evict casual amateurs because of fear about how the photographs may be used. Considering the firepower and egos that some security staff have, photographers should exercise restraint and good judgment when confronted by overbearing or unreasonably suspicious personnel. When such personnel act inappropriately, your chances of prevailing in the field are remote. In most cases, photographers will be better off by acquiescing and then diplomatically resolving matters with senior officials in the public affairs office. Persons who anticipate that they may be photographing sensitive facilities or equipment should consult with the public information office at the facility to obtain permission ahead of time. Not only does obtaining explicit permission obviate concerns about the legality of the photography, in many cases it will lead to better access and cooperation from security personnel.

> In some instances attitudes within the services may conflict.

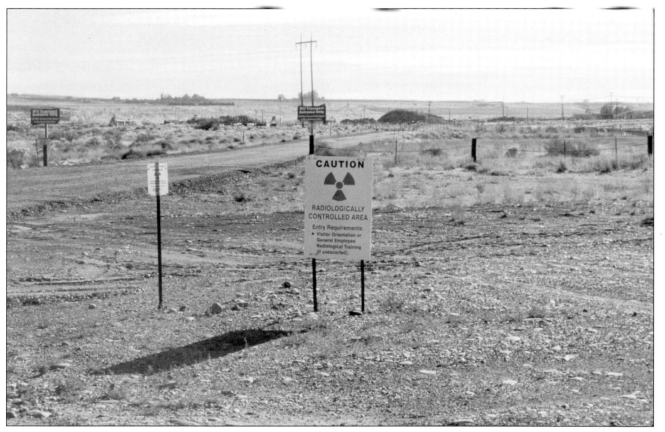

Although the federal government has the power to designate individual nuclear facilities as off-limits to photography, most power plants and radiological areas may be photographed.

○ Copyrighted Material

Fortunately, copyright law has not crippled photography.

Copyright law in theory could impose substantial potential restrictions on photography although the legal issues go mostly unnoticed. While many photographers are aware that their images are protected from unauthorized use and copying, few consider the vast extent of copyrighted material that is routinely reproduced in photographs. For example, copyright protection covers not only written materials and art, it can extend to patterned fabrics, jewelry, toys, and sculptural ornamentation. Common kinds of copyrighted materials that are unwittingly incorporated into photographs include newspapers, billboards, and sculptures in public places. Taken to an extreme, copyright considerations would place enormous restraints on photography since it is impossible to avoid including copyrighted elements in many photographs.

Fortunately, copyright law has not crippled photography because of the practical limits on its reach. Unfortunately, determining where those limits lie is not always easy because copyright law is a very messy area with regard to determining the point at which copying subjects someone to liability. In its basic essence, copyright law prohibits the copying of protected materials unless one obtains permission from the owner of the copyright. Violators who infringe a copyright are liable for the actual damages they cause and in some cases can be required to pay statutorily-prescribed damages and the legal expenses of the copyright owner. What keeps copyright law from crippling general photography is that courts apply the doctrines of fair use and *de minimis* use to allow unauthorized copying under circumstances where the interest in fostering free expression or avoiding litigation over trifles is more compelling than the interest in protecting intellectual property rights. However, applying these doctrines requires courts to decide each case on its own facts, which means that one's rights and liabilities cannot always be assessed with certainty ahead of time. The dearth of published court decisions involving infringement of copyrights by photography further increases the difficulty of assessing whether taking a photograph will infringe a copyright.

From a practical perspective, the potential for infringement can be analyzed by asking three questions. First, will the photograph encompass an object that is protected by copyright? Second, will taking a photograph actually constitute making a copy? Third, will taking the photograph constitute the kind of infringement that will allow a copyright owner to recover damages? In many cases, the determination will depend on how the photograph is ultimately used. To avoid being liable for contributing to an infringement, photographers should be careful about how their photographs may be used.

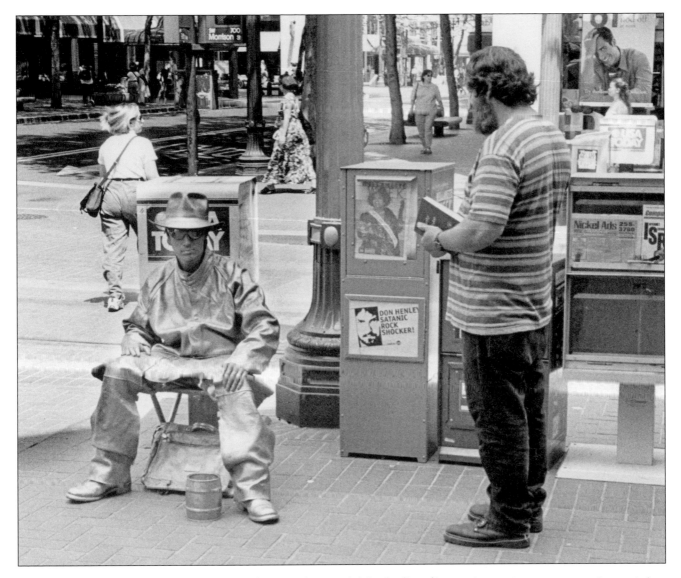

Copyright law protects a variety of created material including literary works, motion pictures, sculpture, choreography, dramatic works, architecture, and graphical works such as drawings and photographs. Under current law, works are protected once they are expressed in fixed form. The former requirement to register the work with the Library of Congress or to display a copyright symbol has been abolished, although doing so enhances the ability of the copyright owner to recover for infringement. While abolishing the need to register works and display the symbol has made copyright protection more practical for photographers, it also increases the risk of inadvertently infringing copyrights.

The type of work can affect the extent to which taking a photograph may infringe a copyright. Literary works, graphical works, and sculpture are protected from any copying that is not authorized by the copyright owner or otherwise permitted by an exception from

The profuse amount of copyrighted work on public display would cripple photography if permission were always required from every owner. There are over a dozen items in this photograph that could be protected by copyright. The apparent sculpture is a man who decorates himself and sits motionless for extended periods.

Architectural works are protected by copyright to some degree.

copyright protection. Choreographical works and pantomime are protected only if the movements and patterns are first recorded in a tangible form such as diagrams or video. This means that the dance sequences in a choreographed stage play can be protected, while spontaneous informal dancing and simple dance routines cannot. Architectural works are protected by copyright to some degree but the copyright statutes specifically allow anyone to take and distribute photographs of buildings that are located in or ordinarily visible from a public place. However, artistic elements associated with buildings such as sculptural ornaments may receive independent copyright protection as visual art and the actual plans and written specifications are protected as visual and literary works.

Sometimes parties claim that they have a copyright in objects that are not eligible for copyright protection. For example, colleges and sports franchises cannot copyright the performances of their athletic teams, although they may acquire the copyright to the televised footage. Similarly, owners of natural things such as trees and manufacturers of utilitarian items such as automobiles and toasters cannot claim copyright protection for their natural or industrial designs. Certain kinds of expression cannot be copyrighted, even when they have been fixed in a tangible form. Names, titles, and short ordinary phrases are one example, and type fonts and familiar symbols such as

Short ordinary phrases, such as the ones on this sign, cannot be copyrighted.

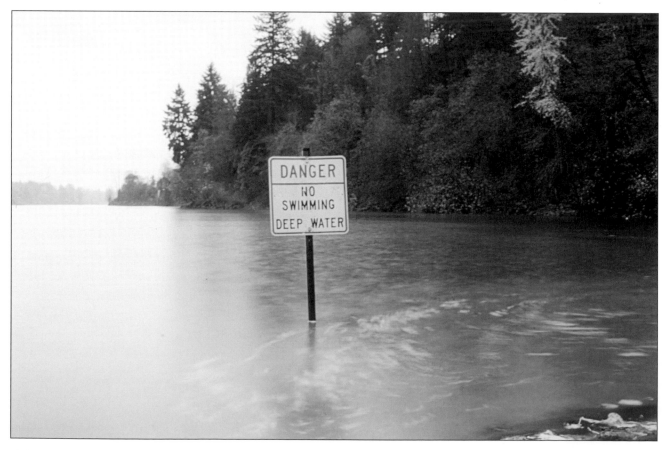

those on playing cards are another. Since these items cannot be copy-righted, they may be freely photographed. In addition, works that are in the public domain are not protected by copyright. Such works include text prepared by the federal government and materials for which the copyrights have expired due to time. The laws regarding expiration of copyrights are complex and it can be risky to assume that particular materials are in the public domain. Additional information about the expiration and renewal of copyrights can be found in texts on copyright law.

The issue of whether a photograph actually copies a copyrighted work is critical when determining whether it infringes the copyright. To constitute a copy, it is not necessary to copy something exactly or completely to be liable under copyright law. The legal test is whether the copy is substantially similar to the original work. One of the relevant considerations is the amount of the work that is included in the photograph. For example, a photograph that includes such a small portion of an artwork to render it unrecognizable to the average layperson would not be considered copying. However, it is important not to confuse this principle with the amount of space that the copy-righted work occupies within the photograph. Including a recognizable portion of a copyrighted work, even though it constitutes a small part of the photograph, could still be considered copying since the relevant issue is the amount of the infringed work that is copied and not the extent to which the work occupies the copy. In other words, a photograph in which a painting takes up a minor area would still be copying if the painting is recognizable.

The qualitative aspects of how the copyrighted work appears in a photograph will also affect whether a work is considered to have been copied. If the work is sufficiently blurred or shaded to be unrecognizable to the average layperson, then it will not be considered to be copied under copyright law. However, copyright law does not require perfect focus and exposure before a court can find that a work has been infringed.

The fact that a photograph copies something that is expressed in a different medium does not mean that the photograph will not infringe the copyright since derivative works are covered by copyright law. Any work that is based on a preexisting work is a derivative work. This means that taking photographs of works such as choreographed dance or sculptures can constitute copying and thus have the potential to infringe copyrights.

Copyright law protects the way that an idea is expressed but does not protect the ideas themselves. The fact that someone else has used a particular idea regarding subject matter or technique does not pre-

> The issue of whether a photograph actually copies a copyrighted work is critical.

clude others from doing so later. For example, taking a photograph of Half Dome in Yosemite National Park does not infringe copyrights despite the fact that other photographers and painters have made works depicting the mountain. Even the duplication of the major elements such as lighting, perspective, subject, and background will not infringe a copyrighted pictorial work if the photograph was created independently. However, deliberately replicating a particular photograph by incorporating its dominant elements can infringe a copyright if the resulting image is substantially similar. Unfortunately, there are no clear boundaries for how similar a work must be before it infringes another. For example, one court ruled that a jury would have to decide whether a set of photographs of a statue in a cemetery infringed a prior photograph of the same statute in the same cemetery since they used the same subjects and similar camera angles, lighting, and composition. In another case, a court ruled that a jury could find that a photograph of a saxophone player infringed one made of a concertina player where both photographs were taken in the same corner of a nightclub with similar lighting, angle, and camera position.

Some courts have suggested that private copying would constitute a de minimis use such as taking photographs for personal use of children standing around a public sculpture.

Considering the extent of copyrighted work that is visible in everyday life and the difficulty of excluding it from photographs, the law provides two exceptions from liability for infringement. One of these doctrines is known as the *de minimis* use doctrine, under which

courts refuse to waste their time on trivial matters. However, as is the case with much of copyright law, it is not always easy to determine whether a particular use is *de minimis*. The few published decisions that have discussed this issue suggest that purely private copying may qualify as *de minimis* use, but neither the courts nor Congress have made this an explicit doctrine. For example, one court ruled that a company's internal use of a competitor's product photograph in a mock-up of a package design was too trivial to warrant damages. The same court alluded that private copying, such as making a photocopy of a New Yorker cartoon to post on one's refrigerator, would also be a *de minimis* use. Nonetheless, when evaluating whether an infringement would be *de minimis*, it is important to remember that infringement is ultimately in the eye of the courts and that one's subjective opinion that a copy is trivial will not be controlling.

The most important exception to copyright infringement is the fair use doctrine. This doctrine is intended to balance society's need to protect intellectual property against the benefits of being able to use copyrighted materials for some purposes without having to compensate the copyright owner. Applying the fair use doctrine always requires consideration of the facts at hand, although courts generally evaluate the use against four factors. Since courts are required to consider the totality of the circumstances, they will not necessarily give each of the factors equal weight when determining whether a particular instance of copying constitutes fair use. This means a party need not prevail on every factor to be entitled to make fair use of a copyrighted work. The four factors are:

The Purpose and Character of the Use. Using copyrighted material for noncommercial purposes such as news reporting, commentary, and education is more likely to be considered fair use than using it for direct commercial gain. Fair use is rarely found when the purpose of the copying is to exploit the material for commercial gain in situations where the customary practice is to pay a licensing fee. With respect to photography, the nature of the use is typically an important factor in determining whether incorporating copyrighted objects into an image is fair use. Photographs of copyrighted objects used for commercial purposes such as advertising are less likely to be construed as fair use than those used to illustrate news, commentary, and criticism. Fair use is particularly disfavored when the copy serves essentially the same function as the original. For example, a photograph used in a newspaper to illustrate a riot that incidentally contains a copyrighted sculpture would be accorded fair use since the sculpture adds little if any significance to the dominant subject matter. On the other hand, an artistic photograph of the sculpture that was mar-

It is not always easy to determine whether a particular use is *de minimis*.

keted as fine art might not be considered fair use. However, highly transformative copying that alters the original work by adding a new expression or meaning can be fair use. For example, Paramount Pictures parodied a photograph of Demi Moore taken by Annie Leibovitz in its marketing campaign for the film *Naked Gun 33⅓: The Final Insult.* The Leibovitz photograph showed the then pregnant actress in the nude with a serious expression whereas the Paramount Pictures version showed a pregnant female body with the smirking face of the actor Leslie Nielsen superimposed. Although the photographs used almost identical poses, the court ruled that no infringement occurred because it perceived the Paramount Pictures photograph as commentary on the Leibovitz photograph. Absent this implied commentary, Paramount Pictures likely would have been found liable for infringement.

The Nature of the Copyrighted Work. Photographs that incorporate informational works are more likely to be construed as fair use than those incorporating creative works. For example, a photograph that incorporates text written on a classroom chalkboard is less likely to infringe a copyright than one that includes a work of fine art. Courts sometimes give parties more latitude to copy published or publicly visible works. For example, courts would be more likely to find fair use associated with photography of public art works than those in an artist's private collection.

The Amount and Substantiality of the Work Copied. This factor may be less relevant to photography than to other media since photography tends to copy all or most of a work. What a court will evaluate is whether the amount copied from a copyrighted work was excessive in relation to the legitimate use of the copy. This factor can be very important when evaluating whether a literary work has gone beyond fair use in quoting or borrowing from other works, but is seldom given much weight in cases involving photography because the other factors are more relevant.

The Effect of Use on the Market or Value of the Copyrighted Work. Courts seem to weigh the fourth factor more heavily than the others, irrespective of the medium in which the work is copied. Photographs that do not materially impair the marketability of the works they copy are far more likely to be accorded the benefit of fair use than those that will cause the copyright owner to lose sales. For example, one court ruled that the reproduction of fine art postcards in reduced size and quality in a magazine would not serve as a substitute for someone wishing to collect art or send postcards. Another court ruled that a film company did not infringe the copyright of artwork on a mobile that was portrayed sporadically in a motion picture

Courts sometimes give parties more latitude to copy published or publicly visible works.

because the film was no substitute for the artwork. However, it is important to consider the potential for derivative works in evaluating the effect on marketability. For example, if a photograph would diminish the potential markets of the copied work in the form of posters, cards, and books, this factor would dictate against fair use.

As noted earlier, assessing whether a photograph may violate a copyright is often a judgment call and photographers are sometimes tempted to view the factors in the light that favors the outcome they desire. Since courts and jurors ultimately make these decisions, it is important to be objective when deciding whether it is safe to copy someone else's work. Also, photographers should not rely on the rationalization that copyright owners will not pursue their remedies because they benefit from the publicity generated by the photographs. Many copyright owners zealously protect their intellectual property and do not attach much value to the publicity. There are others who are not only grateful for the publicity but also for the opportunity to extract some money from the alleged infringer. In other words, the fact that you think you are paying someone a compliment may not protect you from having to pay them damages and legal fees.

○ Trademarks

Trademarks are the names, symbols, and advertising slogans used by sellers to distinguish their goods and services from others in the marketplace. Many sellers zealously defend their trademarks because of the important role they play in marketing and their association with the reputation of the seller. Since most companies are uncomfortable with not having control over how their trademarks are used, the inclusion of trademarks in photographs can be a sensitive issue. In recent years, a trend has developed where owners are claiming they hold trademarks in the shape of famous properties such as classic buildings and that images of these properties infringe their marks. The primary motive of such owners is to obtain licensing fees from persons who market the images although to date they have not been successful in court. Nonetheless, since trademarks are everywhere, photographers should be generally aware of the legal issues associated with taking photographs that include trademarks.

The good news is that, unlike copyright law, trademark law does not restrict the copying of marks by means such as photography. This means that there is no liability for taking photographs that are used for editorial or private purposes. What trademark law does prohibit is using a likeness of a trademark in a way that can cause confusion over the sponsorship of goods or services. The bad news about trademark

> Trademark law does not restrict the copying of marks by means such as photography.

law is that determining whether an image will cause confusion is subject to the same level of uncertainty associated with determining fair use under copyright law. Photographers should also be mindful that the graphic elements used in trademarks are sometimes protected by copyright law and take this into account when photographing a trademark.

One of the threshold elements when analyzing whether a photograph could infringe a trademark is whether the subject in the photograph is in fact a trademark. For a trademark to be a property right, it must be used in connection with an established business or trade. Private symbols and text that are not connected with commerce cannot be trademarks. Trademark owners must also be able to prove that the mark is sufficiently distinct to make a commercial impression. In other words, the mark must be recognized as a symbol of a product or commercial enterprise. For example, the Rock and Roll Hall of Fame sued a photographer for selling photographs of its building in the form of posters. Although the building shape had been registered as a trademark, the court ruled for the photographer on the grounds that the Rock and Roll Hall of Fame failed to prove that it had used the building design shape in a manner that was sufficiently consistent and repetitive to make the images of the building into one of its trademarks. This does not mean that it is impossible for a building shape to be a trademark but it takes more than the owner declaring it to be one.

Claims of trademark infringement involving the reproduction of trademarks in images are usually decided based on whether the image is used in a way that is likely to cause confusion regarding the affiliation of the trademark owner to the image. If there is a reasonable possibility that a person of reasonable intelligence will believe that an image was sponsored or endorsed by the trademark owner then a court will find that the mark has been infringed. However, courts have been inconsistent in how they evaluate the possibility of confusion, which makes it difficult to discern clearly what uses are permissible. For example, one court ruled that wearing a uniform similar to the one associated with Dallas Cowboys Cheerleaders in a pornographic movie constituted infringement because one might assume the cheerleader's organization approved the use of the uniform in the film. However, another court ruled that a poster portraying a pregnant girl in a Girl Scout uniform did not infringe a trademark because no one would believe that the Girl Scouts organization would sponsor such a poster.

Among the factors courts consider in assessing the possibility of confusion are whether the products compete with each other and

This does not mean that it is impossible for a building shape to be a trademark.

Trademarks are everywhere and photographers should not worry about liability for making images that depict trademarks in ways that do not call attention to themselves. This photograph of a pile of garbage shows several trademarks but the prospect that consumers will imply sponsorship by the trademark owners is nil.

whether consumers will mistakenly believe the product is associated with the owner of the trademark. For example, if a trademark owner sells articles that depict its trademark such as shirts, posters, and coffee mugs in addition to its primary products, a court would be more likely to find infringement by products with similar images. Conversely, a court is not likely to find infringement from an image used to illustrate a magazine article comparing product brands since consumers are unlikely to construe sponsorship in such articles.

Many states have laws that protect trademarks from being tarnished or diminished in value even if there is no possibility of confusion on the part of consumers. These antidilution statutes are intended to protect against abuse that diminishes the positive associations with a mark. However, liability under such statutes requires that the mark be used in a commercial context such as on posters or clothing. For example, one court enjoined sales of a poster that displayed the text "Enjoy Cocaine" in a logo stylized to resemble the Coca-Cola logo. Purely editorial uses such as in news reporting and commentary are protected by the First Amendment provisions allowing for free speech. However, using someone's trademark in your products or in advertisements could result in liability if a court believes you are trying to appropriate some of the goodwill associated with the mark.

Consumers are unlikely to construe sponsorship in such articles.

○ Nudity and Pornography

With certain exceptions discussed later in this section, the First Amendment makes it lawful to photograph nude adults and adult pornographic activities provided the resulting images are not obscene. In popular usage, nudity means the unclothed body, pornography means materials that are intended to arouse sexual

desire, and obscenity means language or images that are lewd and disgusting. The legal criteria for determining obscenity were set by the United States Supreme Court as a three-factor test in *Miller v. California*. Under the *Miller* test, an image is obscene if (1) the average person applying contemporary community standards would find that the work taken as whole appeals to the prurient interest, (2) the work depicts specifically defined sexual conduct in a patently offensive way, and (3) taken as a whole the work lacks serious artistic, political, or scientific value. Under this test, two key elements for finding that material is obscene are the wording of the state or local laws governing obscenity and the standards of the community where the images are made or exhibited.

With the exception of child pornography, federal law does not prohibit the making of obscene images but only their distribution. This means that the liability of photographers for making obscene images will be determined by state or local law. As noted in the second part of the *Miller* test, states cannot make obscenity illegal unless they first define by a statute or ordinance the kind of conduct that may be obscene if depicted in a patently offensive way. There is a great deal of variation in how states and localities define obscenity and individual statutes and ordinances should be consulted for specific details. For example, some states narrowly limit their definitions to sexual activities whereas others encompass some forms of nudity and excretory functions. States may also define obscenity in different ways depending on the context. For example, a state might choose to define obscenity in the context of making images of sexual conduct or sadomasochistic abuse but extend the definition to encompass any postpubescent nudity with respect to materials that are furnished to minors.

Irrespective of obscenity, a practical issue for those who photograph nudes or pornography is how the law governs where persons can legally be nude or engage in sexual activities. Governments have flexibility in regulating nudity and sexual activity in public places and may freely prohibit them where they are likely to be in public view. Statutes and local ordinances vary significantly throughout the country and it is necessary to consult the requirements that apply to the particular jurisdiction for specific information. Many states and localities have laws that make it a criminal offense to photograph people nude without their consent in places where they have a reasonable expectation of privacy such as bathrooms and locker rooms. Since the unauthorized photography of persons where they reasonably expect privacy will violate their privacy rights, photographers should be careful not to photograph people without their consent in such places.

> There is a great deal of variation in how states and localities define obscenity.

The federal government and most states have taken strong measures to eradicate child pornography and anyone who photographs minors in any situation that could be construed as erotic should be fully aware of the legal aspects. The government has far more latitude to regulate pornography that involves minors than it does for adult pornography. For example, there is no constitutional requirement that the images be obscene before one can be prosecuted. Because minors are affected, the reach of child pornography laws encompasses a broader range of government interests than is the case with adult pornography. One concern is the welfare of minors used to produce pornography since they lack the legal capacity to consent to acts that result in psychological harm. Legislatures have also expressed concern that pornographic materials depicting minors are used by pedophiles to seduce minors into sexual activity. Since the concerns prompting the legislation consider both the effect of making images on the minor participants and the making of images that will be used as tools to prey on minors, child pornography laws involve comprehensive restrictions on the creation, distribution, and possession of materials deemed to be child pornography.

The federal Child Pornography Prevention Act is a very far-reaching statute. This act not only prohibits the distribution of child pornography, it makes producing any visual depiction of a minor engaged in sexually explicit conduct a federal crime if the materials are intended to be or otherwise become distributed in interstate commerce. The distribution requirement is applied broadly to encompass transportation between states by any means including computer networks or any use of the mail. The act defines explicit sexual conduct as sexual intercourse of any kind, bestiality, masturbation, sadistic or masochistic abuse, and lascivious exhibition of the genitals or pubic area. "Lascivious exhibition" has been interpreted by the courts to encompass visual depictions of a child's genitals or pubic area even when covered by clothing if the image is sufficiently sexually suggestive and unnaturally emphasizes the genital region.

Those who are convicted of violating the Child Pornography Prevention Act face severe penalties and photographers who make unlawful visual depictions of minors can be incarcerated for up to ten years and fined up to $100,000. Although courts have some discretion in sentencing persons convicted under the act, they are still required to follow the federal sentencing guidelines, which means that even modest offenders should expect to serve at least fifteen months in prison. In addition to incarceration and fines, convicted defendants can be required to forfeit the equipment used to make and distribute the images. The act also provides victims the right to

The federal Child Pornography Prevention Act is a very far-reaching statute.

sue violators in federal court. Although the statute is phrased in terms of actual damages, there is a presumption that a minor who is a victim will have sustained damages of no less than $50,000.

The act also imposes a recordkeeping requirement on everyone who make images of sexually explicit conduct that applies irrespective of whether the performers are adults or minors. The intent behind this provision is to deprive child pornographers access to commercial markets by requiring secondary producers of pornographic material to verify the age of the performers in the images. Persons who produce film, videotape, and other matter such as books or magazines that contain visual depictions of actual sexually explicit conduct made after 1 November 1990 must keep records identifying the persons who appear in the depictions if the matter either incorporates material that has been or will be shipped in interstate commerce or mailed. Under this requirement, producers of images that depict sexual intercourse of any kind, bestiality, masturbation, or sadistic or masochistic abuse must establish the performers' date of birth from an identification document such a driver's license or passport, make a copy of the identification document that contains a recent and recognizable picture of the performer, and ascertain and record all names used by the performers including their current legal names, maiden names, aliases, nicknames, and stage names. They are also required to categorize the records so they can be retrieved by all the names used by the performers and maintain them for as long as the producer stays in business and for five years thereafter.

States also have strict laws against child pornography. Most of these laws are analogous to the federal act, although they do not require any relationship to distribution in interstate commerce. The child pornography laws in many states go beyond the federal legislation by requiring film processors who have reason to believe that a minor has been depicted in a sexually explicit manner to report that fact to an appropriate law enforcement agency. This has created concerns among many photographers that photo processing labs have become the arbiters for determining which images constitute child pornography. This concern overstates the role of processors since their opinion is legally irrelevant to determining guilt or innocence. Nonetheless, the fact that processors have a statutory duty to report child pornography to authorities means that one may want to use judgment to assure that film is not sent to a processor that misunderstands the reporting requirement or overcautiously construes the child pornography laws.

There are reasonable measures photographers can take to ensure that they do not run afoul of child pornography laws. Liability under

... their opinion is legally irrelevant to determining guilt or innocence.

the federal laws is predicated on images that depict sexual conduct or lascivious exhibition of genital or pubic areas and some states may extend liability to lewd exhibitions of other parts of the anatomy. Photographers can avoid the risk of the images being construed as pornography by not taking photographs of the conduct and anatomical parts described in the statutory definitions. However, photographs that show a child's intimate areas are not unlawful so long as they are not lascivious. The factors considered by courts in determining whether an exhibition is lascivious include whether the focal point of the depiction is on an intimate area, whether the setting is sexually suggestive, whether the pose is sexually suggestive or inappropriate considering the age of the child, and whether the depiction is designed to elicit a sexual response from the viewer.

○ Animal Photography

Nature photographers should be aware that the Marine Mammal Protection Act and the Endangered Species Act prohibit, among other things, the harassment of protected species. The agencies that enforce these acts give the term "harassment" a broad interpretation and have assessed fines for conduct such as feeding wild dolphins and releasing captive dolphins into the wild before they were capable of surviving on their own. Practices to avoid when photographing protected species are touching, approaching too close, following, and blocking escape routes. Nature photographers should also be aware that actions that individually would not stress protected animals can constitute harassment if their cumulative effect causes stress. For instance, a pod of whales might be comfortable in the presence of a single boat but become annoyed when followed by five or six. The National Marine Fisheries Service and U.S. Fish and Wildlife Service have published guidelines that can help photographers avoid charges of harassment.

States also have laws that prohibit the harassment of wildlife although they tend not to interpret harassment as broadly as the federal statutes. For example, these laws tend to be enforced against more egregious offenses such as actively chasing animals or tampering with nests. However, they protect a broader range of species than the federal laws. Some states provide for the protection of wild plants as well. Although the dominant thrust of such statutes is to prohibit the removal of protected species for commercial or ornamental purposes, many statutes and rules are broad enough to apply to any damage such as pruning or crushing. Lists of protected species can usually be obtained from state resource agencies.

States also have laws that prohibit the harassment of wildlife.

○ Permissible Subjects

There exists a considerable body of informal photographic lore that certain subjects are off-limits to photographers although in fact they are not subject to legal restrictions. In some cases, the belief that something cannot be photographed originates from misunderstanding a requirement about how a photograph may be lawfully used. For example, the fact that one cannot use photographs of celebrities in advertisements without their permission does not mean that people cannot take photographs of celebrities seen walking down the street.

A common misconception is that it is unlawful to take photographs of accidents, crime scenes, or places where emergency personnel are rendering medical attention. While police and medical personnel often disapprove of such scenes being photographed and victims and their family members may intensely resent such photographs, photographers are within their legal rights to record these

scenes when in public view provided they avoid interfering with emergency operations and obey the reasonable orders of police. When photographers have been convicted for activities associated with the photography of accident or crime scenes, it is almost always because they actively interfered with police or medical activities or disregarded orders lawfully issued to protect public safety.

Many photographers are uncertain about their rights to take photographs of children without authorization from parents or guardians. There are no general legal restrictions that prohibit photographing children, although unauthorized photography can arouse suspicions. For example, it is not unusual for people to summon the police when they see a stranger taking photographs of children at a school or public park. For this reason, many photographers refrain from photographing children they do not know unless they have permission from a parent or school officials. Another misconception on the part of some school administrators is that schools may not allow children to be photographed on school premises without a parent's permission. This belief seems to have its origins in the Family Educational Rights and Privacy Act, which limits the disclosure of student records by schools without the parent's written consent. However, the act does not prohibit the photography of students. The use of children as paid models may be restricted by federal and state child labor laws. These requirements vary among the states but gen-

> **Many photographers are uncertain about their rights to take photographs of children.**

There are no legal restrictions against taking photographs of Superfund sites.

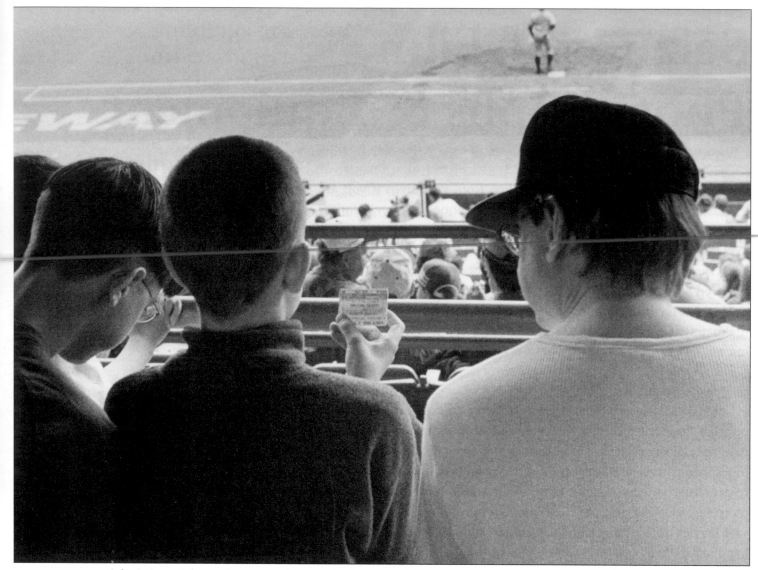

Admission tickets often contain restrictions on photography at concerts and sporting events. Since these restrictions are frequently expressed vaguely and untimely, photographers may want to get a clearer explanation from the facility or promoter beforehand to avoid problems.

tion and whether the balance between the damage to the interests of the property owner and the loss to the photographer is fair and reasonable. For instance, courts would give more credence to a consent form signed by a visitor that authorizes seizure inside a defense plant where photography is strictly controlled than they would to an illegible sign posted inside a dimly lit nightclub that stated the same.

Concerts and sporting events often prohibit or limit the use of photographic equipment. Legally, the facilities and promoters have no right to take your equipment but do have the right to bar your entry if you insist on bringing it. The promoters of some events provide the patrons with adequate notice ahead of time and occasionally provide facilities to check in equipment during the event. At the other extreme are facilities and promoters that give patrons the option of disposing of their cameras or foregoing the right to attend. Such practices are unconscionable and should be protested.

The limitations associated with attending an event are typically printed on admission tickets but are often expressed too vaguely to provide clear guidance to attendees. For example, text stating that "cameras, video recorders, and tape recorders are subject to promoter's authorization and may not be allowed into the facility" leaves too much room for interpretation since "may" could be construed in several ways. If in doubt about a facility's policy regarding photography, it is sometimes helpful to call beforehand to get more information.

Processing laboratories concerned about obscenity or child pornography sometimes seize suspicious images and turn them over to law enforcement agencies. Many states have made it a crime for laboratories not to report images that depict sexually explicit conduct involving children or that show genitals in a lewd manner. Since laboratories and their employees not only face criminal fines and incarceration but also the forfeiture of their equipment, many will notify law enforcement upon the slightest suspicion that an image could be construed as child pornography. In other cases, laboratories have refused to return materials they considered obscene for fear of liability under statutes criminalizing obscenity. Courts have generally upheld this conduct. Photographers concerned about having lawful images seized by overzealous or fearful laboratories should inquire about a laboratory's policy before submitting materials for processing.

Sometimes private parties, particularly security guards, will justify an attempt to seize film or equipment on the grounds of making a citizen's arrest. Since the taking of photographs is rarely a crime,

> The limitations associated with attending an event are typically printed on admission tickets.

private parties cannot arrest you merely because you have taken photographs when they would have preferred otherwise. Similarly, while private citizens have some rights to arrest people, they have no analogous right to seize property. Most states limit the right of private parties to arrest others who have committed a crime in their presence when they reasonably and objectively believe that the particular person has committed a crime. In such cases, a person may use reasonable force to restrain the perpetrator until they can be turned over to a peace officer. Specific limitations on citizen's arrests vary widely among the states. For instance, some states limit such arrests

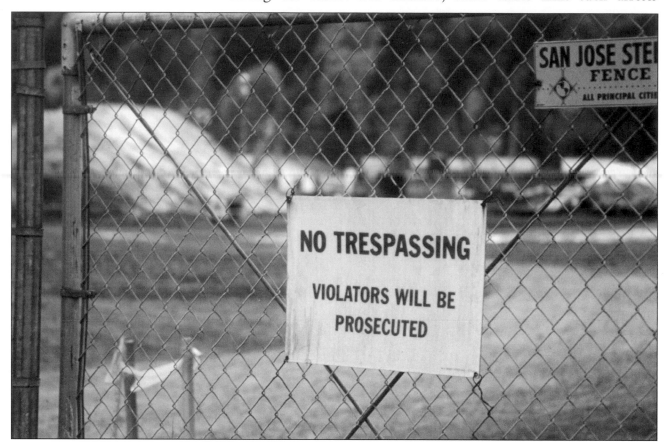

They can threaten to prosecute you but they cannot take your film.

to felonies while others allow arrests for any crime if committed in the presence of the arresting party. Most states require that the arrested party be turned over to a law enforcement official as soon as possible. Citizens have been liable for restraining an arrested person for periods as short as an hour before calling the police. In the event someone detains you on the grounds of making a citizen's arrest, you should demand that they immediately summon a law enforcement official. If they fail to do so, they can be held liable for false imprisonment.

In theory, a photographer who has had his or her equipment seized has the right to arrest the person who took their property pro-

vided that the seizure constitutes a felony or occurs in a state that allows arrests for any crime that occurs in the presence of the person performing the arrest. However, there are good reasons to refrain from this tactic. First, using force or the threat of force can lead to a dangerous altercation. Second, you run the risk of being liable for assault in the event you wrongly assessed that the conduct for which the arrest was made was a crime. Third, as discussed in the next chapter, there are better options such as techniques to defuse confrontations and the pursuit of legal remedies.

Likewise, a photographer has a qualified right to use force to resist someone who is unlawfully attempting to seize equipment or film but in many cases should refrain. As stated above, photographers in these situations generally have better and safer options at their disposal. In addition, you could be legally liable if you use excessive force. When defending property, you may resort to force only if you reasonably believe it is necessary to prevent theft or destruction of the film or equipment. Many states require you to take reasonable measures such as requesting the person to desist before resorting to force. The use of deadly force is never authorized to defend property, and weapons such as guns or knives cannot be lawfully used to prevent a seizure.

> Photographers in these situations generally have better and safer options at their disposal.

O Government Seizures

The government may lawfully seize images, film, and equipment when they may constitute evidence of a crime. Since there are relatively few instances in which taking photographs is a crime, photographic equipment is rarely seized outside of cases involving counterfeiting, obscenity, or child pornography. However, the potent evidentiary value of images makes them a frequent target of seizure. Except in limited circumstances such as during the course of an arrest, law enforcement agents cannot seize someone's film or equipment without a warrant or subpoena authorizing them to do so. In the event you are arrested or ordered to hand over film or equipment, you should do so since there is no legal right to use force against law enforcement agents who are acting pursuant to their official authority. Doing so will subject one to being charged with resisting arrest. In such cases, your best alternative will be to try and resolve this matter with senior officials or, if that fails, to pursue legal action.

Search warrants are judicially approved orders that authorize law enforcement agents to enter onto property without the owner's consent and seize materials that may constitute evidence of a crime. Although warrants grant much authority to law enforcement, they

are also subject to strict constitutional limits. For instance, a court cannot issue a warrant unless an agent establishes probable cause that a crime has been committed and explains why evidence can probably be found at the place described in the warrant. A warrant must also describe the nature of the crime and identify the items or types of items that are intended to be seized. Theoretically, warrants cannot authorize indiscriminate searches although in practical effect they often do. In addition, evidence that is not described in a warrant but is incidentally discovered may lawfully be seized. In the event you are on premises subjected to the execution of a warrant, you should be careful not to interfere with the search. Removing or concealing materials described in a search warrant constitutes obstruction of justice and should be avoided. If agents want to search an area not described in a search warrant or seize items not specified, you may request they refrain but should otherwise not resist. Officers are supposed to supply an inventory of seized goods following the execution. Needless to say, if you or your property are the subjects of a search warrant, you should immediately seek legal counsel for assistance in protecting your interests.

Administrative agencies often have the power to require regulated parties to produce documents and images for inspection and copying when necessary to carry out an agency function. These powers can be exercised in the form of an administrative order or during inspections and compliance visits. An agency's authority will be defined by the statutes that prescribe its authority to collect information. Few statutes give agencies the power to collect information from unregulated parties. For example, a pollution control agency might be able to require a wastewater discharger to provide information and images regarding its discharges but could not force an independent photographer to produce the same.

O Subpoenas

Subpoenas should always be taken seriously since failure to comply can result in substantial sanctions. A subpoena is an order from a court issued on behalf of a party to a legal proceeding that requires someone to testify or produce documents or other items for inspection and copying. Photographers sometimes receive subpoenas when they have recorded something that interests a party to a lawsuit. Typical situations are accident scenes, riots, and filmed interviews. Many photographers resent subpoenas because they are inconvenient and require them to provide a valuable product at a fraction of its market value. Unfortunately, few remedies are available to alleviate this burden.

> **Few statutes give agencies the power to collect information from unregulated parties.**

Subpoenas may be issued on behalf of private parties or the government in civil or criminal actions. While technically issued under a court's jurisdiction, subpoenas are usually prepared by the parties to a legal proceeding without court supervision or approval. The subpoena must describe the materials with sufficient detail to allow the photographer to determine what materials are being sought and the time and place to produce them. If you have doubts about what is being sought, the party issuing the subpoena will usually be willing to clarify the request. In cases where someone has issued a subpoena for images that were prepared for a customer, it is a good practice to inform the customer prior to complying with the subpoena to give them an opportunity to challenge it. Work prepared for attorneys is frequently protected from disclosure and it is imperative in such cases to contact the attorney before responding to the subpoena.

Subpoenas frequently request excessive materials or set an unreasonable schedule. Often, the parties to a litigation will draft overbroad requests out of fear that they may miss an important image if the material sought is described too specifically. Similarly, attorneys sometimes set unrealistic deadlines because they do not understand the amount of time needed to find and produce the requested materials. When faced with an unreasonable subpoena, you should attempt to work out an accommodation with the party that issued the subpoena. Many times, the party requesting the images will be satisfied if you describe the materials you possess that seem relevant and produce them instead of everything that is technically demanded by the subpoena. This can sometimes save you a lengthy and burdensome search. However, you must obtain the party's consent before you can partially respond to a subpoena.

If you are unable to work out differences with the party that issued the subpoena, your only option is to file a motion with the court to modify or quash the subpoena or serve the parties with a formal objection. Since you will probably need to hire an attorney to do this, efforts to reach an amicable resolution directly with the issuing party should not be discounted. In general, one should not expect the courts to excuse you from complying with the subpoena unless it is grossly burdensome, imposes an unreasonable schedule, or requests privileged information. Privileges apply to information that is protected from discovery such as some kinds of work done for attorneys. In some cases, privileges are available to the news media to enable them to protect confidential sources. Courts will not require the parties to compensate you for the market value of the images. However, they will protect you from incurring significant expenses relating to

Subpoenas frequently request excessive materials or set an unreasonable schedule.

Taking photographs of children without a parent's permission in public areas such as playgrounds can invite confrontation since people are sensitive about any behavior on the part of a stranger that is directed toward children.

that some subjects pose unnaturally and destroy the ambiance desired by the photographer. However, many subjects revert to their natural appearance if asked to relax or when given sufficient time to become comfortable with the photographer's presence. It is not always necessary to ask permission verbally. Letting people see you have a camera and smiling indicates your intent to take a photograph and gives them an opportunity to express their comfort by smiling back.

Conflicts with property owners and similar parties can be avoided by using common sense. In some situations, such as photographing

residential structures, it is a good idea to get the owner's consent to avoid causing undue concern. Questions regarding taking photographs at places such as museums can often be asked ahead of time. This applies to events such as concerts as well.

Two other approaches to reducing the likelihood of confrontation are to blend in with the environment or to purposefully stand out. Although these approaches use opposite methodologies, they are based on the common premise that people are more comfortable with behavior that does not seem inappropriate under the circumstances. Which approach to use will depend on factors such as the setting, type of images desired, and the temperament of the photographer. Experience will provide you with insight as to which approach will work best in a given situation.

Blending in requires photographers to do as little as possible to draw attention to themselves. Casual behavior that suggests there is no pressing purpose behind the photography will tend to be ignored by people even though they are aware of the photographer's presence. As noted previously, furtive behavior tends to alarm people and is antithetical to minimizing attention. Instead of concealing their activities, photographers who use the blending in approach merely try to avoid attracting interest by making their activities seem as mundane as possible. One aspect of doing this is to be attired in a manner consistent with the setting. Wearing a suit at the beach or swim trunks in the lobby of a courthouse are counterproductive to blending in. Another aspect is to use minimal equipment of a type that does not necessarily imply serious photography. Point and shoot cameras and even older rangefinders tend to draw less attention than single lens reflex and large format cameras. Use of tripods and lighting equipment should be avoided when trying to blend in. Some photographers believe that cameras with waist-level finders tend to be less obvious, but this is open to debate since staring down into a box with one or more lenses can attract attention from curious bystanders.

Blending in is easier to do in busy communal places where people tend to act less guarded toward people they do not know. For instance, most people are more comfortable about being photographed by a stranger amid the crowds at a state fair than they will be in a nearly empty public park. Some photographers make it a practice to roam an area so as to minimize their presence in any one place. They find something that interests them, quickly but calmly take a photograph, and move on. Others remain quietly in one location and wait for subjects to come to them.

Furtive behavior tends to alarm people and is antithetical to minimizing attention.

Standing out requires mannerisms that display an authoritative intent to take photographs. This approach tends to make people more comfortable because they feel assured that the photographer has some definite objective that does not pose a threat. This approach is often more suited than blending when a lower density of people makes it likely that the photographer will be noticed. Since the effectiveness of this technique depends on asserting one's visibility, photographers are in many cases better off using professional-looking cameras, tripods, and lighting instead of lower profile equipment.

The effectiveness of this technique depends on asserting one's visibility.

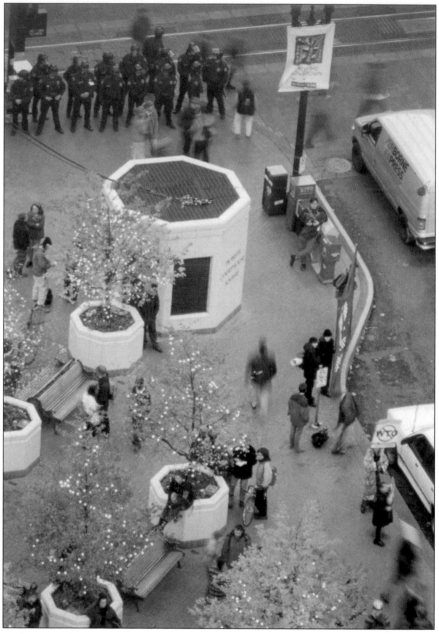

Where's the photographer? Finding a good location and acting nonchalant will help you avoid confrontations, even in potentially tense settings.

○ Dealing with Confrontations

When a confrontation arises, you need to assess where it is likely to head and the best way to deal with the situation. Rather than use pat responses, it is better to analyze each confrontation using a framework that allows you to adapt to the unique aspects of the confrontation. The first question you should ask yourself is how important is the image and what is the purpose for taking it. In many cases you may find that you have no good reason for taking a photograph but were merely attracted to a scene and impulsively decided to photograph it. If the image is one that does not really interest you, it is senseless to engage in conflict over it. On the other hand, knowing why an image is important to you can help in defusing a confrontation. For example, if you are building a body of work documenting your community, being able to explain that objective to other residents can alleviate their concerns or objections.

The second question to ask yourself is what is the interest of the person objecting to the photograph. Too often photographers get so wrapped up in their own work that they fail to consider that others have legitimate interests as well. A photographer who kneels down to photograph a child drinking from a water fountain may know that he intends no harm but parents who see atypical attention by a stranger are within their rights to be concerned. Likewise, a security guard who sees someone setting up a tripod to photograph an industrial facility is supposed to be alert to unusual activity and is not acting inappropriately by politely inquiring about the purpose for the photography. Just because someone expresses interest or concern is no reason to get your hackles up. A rational explanation of your intentions more often than not is sufficient to alleviate concerns and objections.

Viewing confrontations from the perspective of the parties' interests can also form the basis for resolution or compromise even when someone is not entirely comfortable about you taking photographs. Sometimes a willingness to compromise allows the objecting party to save face, which not only hastens the end of a confrontation but allows you to take the remaining images in peace. Common ways for photographers to compromise are to agree to move to a different vantage point or to take photographs at a different time. An offer to compromise can sometimes be used to a photographer's advantage, such as when a security guard agrees to allow you briefly onto a property in exchange for leaving the area once you are done taking photographs.

Reason and a willingness to accommodate other parties are not always effective, and photographers should have a plan with regard to

Knowing why an image is important to you can help in defusing a confrontation.

A cool head and simple courtesy are all that are required to resolve most confrontations. A manager wanted to know the reason for photographing this Superfund site cleanup but freely conceded that it was lawful to photograph it from a public place.

how they will proceed in the face of continued objections. If the confrontation is verbal and unlikely to escalate into violence, you can try to be more assertive with the person expressing the objection. In many cases, a polite but firm statement that you are acting within your rights may cause the person to back down. For example, if a doorman comes out and orders you not to photograph a hotel, a simple statement that you may legally photograph anything in view of your camera when standing on a public sidewalk will demonstrate that you understand the law better than the doorman does. When employees such as security guards and clerks persist in objecting, it is often fruitful to speak to a higher-up in the organization. For instance, the public relations manager of a large hotel is unlikely to object to any photography outside the building and may very well be concerned that the doorman is unnecessarily damaging the hotel's reputation for courtesy.

One thing you should avoid when confronted about photography is lying. Even when seemingly harmless, lying can reduce your credibility and enhance suspicions. Lying can also adversely affect your legal status. For example, someone who consents to an image after a stock photographer misrepresents himself as an amateur may claim the consent was invalid after seeing the published image. In the worst

cases, lying may unintentionally get you into more trouble. For instance, brushing off someone's query about why you were taking pictures in an alley by claiming you are an undercover police officer might not be a good response if the person and his nearby companions are concerned that you have photographed their most recent drug transaction. In addition, misrepresenting that you are affiliated with an organization such as a newspaper can lead to other problems. Not only will the organization be upset if it discovers your misrepresentation, in some cases impersonation might result in criminal charges.

If you are confronted by a law enforcement officer, you should be aware that he or she is probably responding to a complaint from someone who is concerned that you are doing something suspicious. In the event you are stopped and questioned, it is important to act appropriately. Typically, questioning officers will have no reason to believe that you have committed a crime and will be satisfied by answers that indicate that you are doing nothing wrong. It is best to respond candidly when questioned under circumstances when you know you have acted within your rights in taking photographs. For instance, if an officer asks whether you were at a specific location, be frank and admit it. Likewise, be honest regarding your reasons for taking photographs. Misrepresenting your whereabouts and motivations can make the officer more suspicious and may lead to further investigation. In some instances, lying to an officer is grounds for prosecution irrespective of whether you did anything else unlawful. In the event that your activities have been unlawful, candor may work against you. How to respond to questioning in such situations is beyond the scope of this book.

In some cases, it will be apparent that the person making objections is not in a rational state of mind. When a situation escalates to continued interference or other irrational behavior, you may want to consider refraining from taking photographs until a more suitable time or place arises. Although no one likes to be intimidated, yielding in such circumstances is usually the best course since few images are worth the risk of being assaulted. In some cases, it may be appropriate to summon help from a third party such as the property owner or law enforcement. When violence appears to be a substantial possibility it is usually better to leave the area expeditiously, since standing one's ground in such circumstances can invite more trouble. In cases where forcible seizure or assault are implicitly or explicitly threatened, the photographer should summon the police to help defuse the situation. Often, the act of pulling out a cellular phone to call the police will be sufficient to cause the harassing party to back

Typically, questioning officers will have no reason to believe that you have committed a crime . . .

down. Once summoned, law enforcement officials vary in how they treat photographers but in any case should be treated with respect. You should make your complaint calmly, objectively, and maturely. In most cases, they will side with you and tell the other party to desist from further harassment. Occasionally, a law enforcement officer will try to avoid further conflict by telling both parties to leave the area, and there have been some instances where officers have sided with the harassing party. While you technically do not have to obey an unlawful order from a peace officer, the potential consequences may not justify the risks associated with refusing to heed such directives. In some cases, it may be feasible to discuss the matter with the officer's supervisor.

If a party has actually assaulted you or taken film or equipment, you should call for assistance from law enforcement. In many jurisdictions you have the right to file criminal charges such as theft, harassment, and assault even if they agree to return your materials once the police appear. Sometimes law enforcement officials will decline to proceed with charges on the grounds that the conduct is a civil matter. In such cases, the photographer should at least request the officer to collect the names of the parties involved in the confrontation since knowing the identity of the parties will facilitate pursuing civil remedies. Furthermore, the photographer can independently request that the district attorney's office consider filing charges against the party that committed the crime.

There may be some benefits to filing criminal charges besides the social justice aspects. One benefit is that publicity given to such charges can make others in the community more sensitive to the rights of photographers. This kind of publicity is particularly effective to deterring violence or threats of violence by private security personnel. Another benefit is that many states have civil compromise statutes where criminal charges can be resolved by the defendant agreeing to provide suitable restitution to the victim. Although the damages encompassed by these statutes are often small, they can effect a resolution in less time than civil proceedings. Photographers should also be aware that filing criminal charges may have some detrimental aspects as well. First, the photographer will lose some control over how the matter is resolved since all decisions such as the terms of a plea agreement and timing will be made by government prosecutors. Second, if your film or equipment is seized the government may retain it for use as evidence in a trial. Although this evidence will be returned after the trial or entry of a plea agreement, the photographer will be unable to use it until that time.

There may be some benefits to filing criminal charges besides the social justice aspects.

◯ Relief for Photographers

Sometimes reasonable efforts to avoid or dispel confrontation fail and photographers are prevented from photographing or have their equipment or film confiscated. These situations are never pleasant and usually violate the photographer's legal rights. In such cases, a photographer may want to pursue relief by filing a legal action. Understanding the practical aspects of how legal processes work can make obtaining relief quicker, less expensive, and more effective. Similarly, failing to understand how the system works can impair otherwise strong claims.

The first step when you have been unreasonably harassed or had film or equipment seized is to determine what you want in terms of relief. Keep in mind that legal recourse is not always the best or even a practical means of resolving conflicts involving photography. In some cases, the degree of public or legal injury does not warrant seeking a remedy. For example, a press photographer who has been told by a minor school official that he cannot photograph a high school basketball game may not care enough about the matter to want relief. Should the photographer or the newspaper want recourse, options outside the legal system will make far more sense than filing a lawsuit to get access.

The first step in figuring out how one wishes to resolve a conflict is to assess the interests of the parties involved. The newspaper may want to cover high school sports to provide information desired by its readers. The school probably wants only to ensure that the photography does not unduly interfere with the players and fans. Since the decision to limit photography was likely motivated by the poor judgment of a school employee, these kind ofs of matters can probably be resolved quickly and amicably so long as the parties conduct themselves maturely. If a conversation between the photographer and the coach does not resolve this matter, it is likely that a telephone call between the editor and the principal will.

In other cases, immediate recourse to legal action will be warranted. For instance, if security guards seize a photojournalist's film after she photographs employees fleeing a burning building during an emergency at a chemical plant, the newspaper may feel it is imperative to obtain the images before the story becomes stale. Since the newspaper's interest in prompt publication will conflict with the chemical company's interest in minimizing adverse publicity, the newspaper might want to retain an attorney to file an emergency injunction to recover the film and not wait to see if informal efforts at resolving the conflict succeed.

> Sometimes reasonable efforts to avoid or dispel confrontation fail.

Another ethical debate concerns whether photography can lead to the degradation of habitat.

modern nature photographers avoid disrupting habitats but before the "do no harm" philosophy became prevalent, wildlife photographers were often willing to engage in conduct that harmed their subjects. For instance, some photographers trimmed branches around bird nests not realizing that this practice increased the risk of predation. Some photographers even killed animals with firearms to make them stay still. There is now widespread consensus among nature photographers that such practices are unethical.

Another ethical debate concerns whether photography can lead to the degradation of habitat and scenic areas by attracting more visitors. In reality, many nature and landscape photographs are taken in

Whether nature photography results in increased visitation and resulting damage to pristine areas is moot with many nature photographs since they are taken in heavily visited areas anyway. This photograph was taken from the shoulder of a well-traveled road.

heavily visited areas or from well-known viewpoints and are unlikely to increase the number of visitors or further degrade natural areas. Nonetheless, most photographers will want to be careful about publicizing sensitive locations if the attention is likely to cause them to be damaged or destroyed.

A more tangible risk associated with nature photography is that the act of photographing sensitive animal and plant populations can alert curious but less sensitive people to their presence and result in damage to habitats that otherwise would have remained undiscovered. Whereas a responsible nature photographer will avoid disrupting habitats and cease photographing if it stresses animals, casual observers often do not care about the damage they cause or downplay their effect on the environment. Those who wish to ensure they do not damage the environment will not only consider the stress they may cause but also the potential to reveal sensitive areas to those who may act inappropriately.

Photographers should also consider the effect that photographs may have on human subjects, although the moral aspect of holding people accountable for their actions makes photographing people different than for wildlife and natural areas. While photographers should avoid taking photographs for the sole reason of harming someone, it is ethical to photograph people who will suffer as a result when those consequences are morally appropriate considering their conduct. For instance, the videotapes of the Rodney King beating in Los Angeles in 1991 radically changed the lives of the police officers involved but were ethical because the officers were committing acts for which they should have reasonably expected consequences. Nonetheless, photographers should consider whether they want a person to suffer, even when the conduct is intentional. This is particularly true when the probable consequences exceed what the photographer considers fair and reasonable under the circumstances. For example, a high school student falling asleep while working a summer job may present a humorous scene to a photojournalist looking for a human interest image, but it may not be worth getting the student fired.

Sometimes it is not reasonable to hold people accountable for their experiences. Accident and crime victims are rarely morally responsible for their circumstances and should not be photographed without good reason. Similarly, people show different degrees of judgment at various stages of their lives and this should be considered when evaluating the ethics of taking photographs. For instance, a teenager who foolishly decides to skinny dip in public view may deeply regret being photographed. While it is legal to photograph people engaged in

> Photographers should also consider the effect that photographs may have on human subjects.

conduct resulting from ill-advised decisions, photographers should evaluate whether making an image is worth causing pain and embarrassment to the subject.

○ **Ethics of Misrepresenting Facts to Take a Photograph**
Photographers have a long history of deceitful practices intended to gain them access to subjects that otherwise would be denied. Sometimes the motives have been good, such as when Lewis Hines lied about being employed by companies so he could photograph their abuses of child labor. At other times, motives have been quite questionable such as misrepresenting that nude photographs were being taken for educational purposes when the intent was to market them as pornography. Regardless of whether lying brings about good or evil, photographers need to understand they undermine their moral authority by resorting to misrepresentations.

A major problem with misrepresenting one's purpose that many photographer fail to consider is that it can backfire, even when motivated by the desire to achieve a greater good. A case in point was the undercover reporting in 1992 by journalists employed by the American Broadcasting Corporation (ABC) that revealed unhealthy meat handling practices by the Food Lion supermarket chain. Two of these journalists filed job applications and were hired by separate supermarkets operated by Food Lion. While thus employed, they witnessed and secretly photographed improper food handling which ABC later televised. However, the public furor over ABC's tactics far exceeded concerns about the marketing of bad meat. Food Lion sued ABC and the journalists and won a hefty verdict that was reduced to $2.00 on appeal. However, the use of deceit to gain access to the stores fostered a reputation for sleazy reporting that overshadowed the newsworthy nature of the story.

Even minor misrepresentations can adversely affect photography. A lie commonly told by photographers is that they are taking a photography course and need images to fulfill an assignment. While the motives behind such misrepresentations vary, they rarely are intended to harm the subject. Some amateur photographers misrepresent their reasons for taking a photograph because they are self-conscious about photography as a hobby and making up some purpose makes them feel more comfortable. Some professionals misrepresent themselves as amateurs or tourists out of fear that the subject will request money in exchange for being photographed. Although these practices do no harm to the subjects, they seldom result in any great benefit to the photographer. Being candid about why you are taking photographs is often easier when you can articu-

Some amateur photographers misrepresent their reasons for taking a photograph.

late the purpose of your photography. For instance, stating that you are documenting your neighborhood sounds more serious than "I like to take pictures," and is usually more believable than "I'm taking a photography class."

Misrepresenting why you want to take photographs is more serious when done to obtain permission that would probably be denied if you disclosed your true motivations. This kind of deceit is so serious an ethical infraction that it can sometimes expose one to legal liability. In addition, such practices may irreparably damage one's credibility.

Another consideration when one feels that photographing a particular subject will be impossible without misrepresentation is whether taking photographs is the best way to accomplish your objective. In most cases, there are alternatives that can express a message more effectively than photography obtained through deceit. For instance, the ABC journalists might have exposed the Food Lion meat handling practices by interviewing former employees and confronting store managers with evidence. Although the footage may not have been as graphic, the primary message ABC was trying to convey would not have been drowned by the media attention given to the questionable tactics.

> This kind of deceit is so serious an ethical infraction that it can expose one to legal liability.

Conclusion

The law does more to protect photography than it does to restrict it.

ETHICS REQUIRE PHOTOGRAPHERS to think about more than legal requirements when making images. In a large sense, having a sound and considerate ethic about one's photography will go a long way in avoiding legal problems. Photographers should also be mindful that the law does more to protect photography than it does to restrict it. By knowing the legal and ethical issues, photographers can increase their confidence in making images and derive more satisfaction from doing so.

Glossary

Administrative rule: A regulation drafted by a government agency to control regulated parties or establish procedures to be followed by the agency.

Appeal: A proceeding in which the decision by a trial court or government agency is reviewed by a senior court for correctness.

Appellate: Associated with an appeal.

Citizen's arrest: An arrest made by a private citizen as opposed to a law enforcement officer.

Civil: Matters that pertain to private rights and remedies as opposed to matters that pertain to criminal or administrative law.

Civil compromise statute: A statute that allows for someone accused of a minor crime to avoid prosecution by agreeing to compensate the victim.

Claim: An assertion that one has a right to compensation or other action due to a wrong committed by another person.

Classified material: Government documents and information that may be viewed by a limited number of designated individuals.

Clause: A sentence or paragraph that makes up part of a legal document.

Common law: The body of law that is derived from ancient customs as modified and enforced by the courts.

Compensation: Payment or remuneration made to repay someone for a loss.

Confrontation: A face-to-face exchange in which one party objects to the conduct of the other.

Consent: A voluntary act of granting permission.

Consideration: The items of value exchanged for each other in a contract. Examples of consideration include money, services, and the waiver of legal rights.

Contempt: A deliberate act of disobedience to an order from a court.

Contract: A legally enforceable agreement between at least two parties in which they agree to exchange things of value such as services for money.

Copyright: A right accorded to visual artists, writers, and others that protects against the unauthorized copying of their works.

Counsel: An attorney who advises clients of their legal rights or represents them in court or business matters.

Counterclaim: A claim filed by the defendant in a court action seeking compensation from or an injunction against the plaintiff.

Defamation: The making of false statements that damage the reputation of another.

Defendant: A person against whom a court action is filed.

Demand letter: A letter that notifies someone that they will be sued unless they make compensation for an alleged loss within a specified period.

De minimis: Very slight or trifling.

Discovery: Legal procedures that allow parties to obtain facts, information, and documents from other parties to a lawsuit.

Doctrines: See legal doctrine.

Evidence: Proof that may be presented at trial.

Evidentiary ruling: A decision by a court to allow or prohibit a party from presenting certain evidence during a trial.

Fair use: An exception to copyright that allows the unauthorized copying of another's work for a limited purpose.

Federal government: The system of government administered on the national level as opposed to the state or local level.

Felony: A serious crime typically punishable by incarceration for more than one year.

Indemnify: To restore someone for a loss.

Indemnity: An agreement where one person agrees to restore another in the event a loss occurs.

Injunction: An order from a court that requires or prohibits the performance of a specific act.

Invasion of privacy: The violation of a legal right to privacy.

Judgment: The final decision of a court resolving a dispute.

Judicial precedent: A court decision used as authority for determining how the law should be applied in later cases involving similar issues.

Lawsuit: An action filed in court in which someone claims they are entitled to compensation or an injunction as a result of their rights being violated.

Legal doctrine: A rule or principle of law.

Legislative law: Laws enacted by legislative bodies such as the United States Congress.

Liability: Exposure to an obligation to pay compensation or a penalty because of the failure to meet a legal duty.

Licensing fee: A fee paid to a government agency or property owner for permission to carry out an activity or use another's property.

Litigation: The process of contesting claims in a lawsuit.

Loitering: To spend time idly at a specific area or property.

Market value: The price that goods or services would command in the open market.

Mediation: A process where a neutral third party assists others in an attempt to resolve a dispute.

Model release: A document in which a model or legal representative thereof agrees to waive privacy rights with respect to being photographed and published.

Nudity: A state of undress.

Nuisance: An activity that unreasonably interferes with the right of nearby property owners to enjoy their property.

Obscenity: Material that appeals to a morbid sexual interest in a patently offensive way.

Ordinance: A rule or regulation enacted by a city or county.

Permit: A document issued by a government agency that allows someone to engage in an otherwise restricted activity.

Plaintiff: A person who files a court action against another.

Plea agreement: An agreement in which a person agrees to admit guilt to a crime in exchange for a specified punishment.

Pornography: Material intended to appeal to a person's sexual desire.

Privacy right: See right to privacy.

Privilege: (1): A exemption from tort liability in the face of special or unusual circumstances (2): An exemption from having to provide information, documents, or testimony to a party engaged in a lawsuit.

Probable cause: A reasonable ground to believe that a crime has been committed.

Publication: To display or make known to people in general.

Recitals: Statements of fact, law, or reasons in a legal document such as a contract.

Recovery: The compensation obtained as a result of a judgment entered by a court.

Release form: A document where a person agrees to consent to an act or give up a legal right.

Relief: Redress provided by a court such as an injunction.

Remedy: The means by which a legal right may be enforced.

Restitution: See compensation.

Right to privacy: A legally recognized right that protects against the unwanted intrusion into private spaces, unauthorized use of another's reputation for commercial gain, or the public portrayal of a person in a false light.

Sanction: A court order punishing someone for improper behavior.

Search warrant: An order issued by a court authorizing law enforcement officials to search for and seize property that is evidence of a crime.

Securities: A document that evidences an interest in an enterprise or a debt. Examples include stock certificates, notes, and bonds.

Security obligation: See securities.

Settlement: An agreement between the parties that resolves or avoids the need for a lawsuit.

Small claims court: A court in which minor matters are heard.

Stalking: Behavior consisting of following or waiting for a person in a manner that causes a reasonable fear of harm.

Statutes: Laws enacted by legislatures.

Statutory: Pertaining to a statute.

Subpoena: An order issued under the authority of a court that requires a person to provide evidence to a party in a lawsuit.

Tort: A private wrong or injury that is not a breach of contract. Examples include trespass, nuisance, and assault.

Trademark: A distinctive mark or phrase used to distinguish the goods and services provided by one person from the goods and services provided by others.

Trespass (common law or private): The unauthorized entry onto another's property.

Trespass (criminal): The unauthorized entry or remaining on a person's property in defiance of instructions prohibiting one's presence such a verbal request or a posted warning.

Trial: A proceeding at which the parties present evidence and have a judge or jury resolve their dispute.

Verdict: An award issued by a judge or jury before the official entry as a judgment.

Whistleblower: An insider who reports wrongdoing to government authorities or the media.

Index

Heavenly Bodies

THE PHOTOGRAPHER'S GUIDE TO ASTROPHOTOGRAPHY

Bert P. Krages, Esq.

Learn to capture the beauty of the night sky with a 35mm camera. With some basic skill, minimal photographic equipment, and intermediate level astronomical tools, you'll be on your way to getting the images you desire. $29.95 list, 8½x11, 128p, 100 color photos, index, order no. 1769.

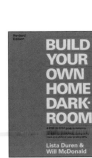

Build Your Own Home Darkroom

Lista Duren and Will McDonald

This classic book teaches you how to build a high quality, inexpensive darkroom in your basement, spare room, or almost anywhere. Includes valuable information on: darkroom design, woodworking, tools, and more! $17.95 list, 8½x11, 160p, 50 b&w photos, many illustrations, order no. 1092.

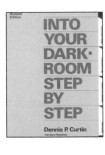

Into Your Darkroom Step-by-Step

Dennis P. Curtin

This is the ideal beginning darkroom guide. Easy to follow and fully illustrated each step of the way. Includes information on: the equipment you'll need, setup, making proof sheets, and much, much more! $17.95 list, 8½x11, 90p, 100 b&w photos, order no. 1093.

Photo Retouching with Adobe® Photoshop® 2nd Ed.

Gwen Lute

Teaches every phase of the digital retouching process, from scanning to final output. Learn to restore damaged photos, correct imperfections, create realistic composite images, and correct for dazzling color. $29.95 list, 8½x11, 120p, 100 color images, order no. 1660.

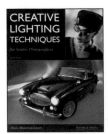

Creative Lighting Techniques for Studio Photographers, *2nd Ed.*

Dave Montizambert

Whether you are shooting portraits, cars, tabletop, or any other subject, Dave Montizambert teaches you the skills you need to take complete control of your lighting. $29.95 list, 8½x11, 120p, 80 color photos, order no. 1666.

Traditional Photographic Effects with Adobe® Photoshop®, *2nd Ed.*

Michelle Perkins and Paul Grant

Use Photoshop to enhance your photos with handcoloring, vignettes, soft focus, and much more. Every technique contains step-by-step instructions for easy learning. $29.95 list, 8½x11, 128p, 150 color images, order no. 1721.

Master Posing Guide for Portrait Photographers

J. D. Wacker

Learn the techniques you need to pose single portrait subjects, couples, and groups for studio or location portraits. Includes techniques for photographing weddings, teams, children, special events and much more. $29.95 list, 8½x11, 128p, 80 photos, order no. 1722.

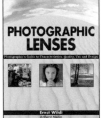

Photographic Lenses

PHOTOGRAPHER'S GUIDE TO CHARACTERISTICS, QUALITY, USE AND DESIGN

Ernst Wildi

Providing discussions on low-dispersion glass, aspheric lens elements, apochromatic lenses, and more, this book will leave you with an ability to select and use a wide variety of lenses to achieve high-quality images. $29.95 list, 8½x11, 128p, 70 color photos, order no. 1723.

Beginner's Guide to Adobe® Photoshop®, *2nd Ed.*

Michelle Perkins

Learn to effectively make your images look their best, create original artwork, or add unique effects to any image. Topics are presented in short, easy-to-digest sections that will boost confidence and ensure outstanding images. $29.95 list, 8½x11, 128p, 300 color images, order no. 1732.

Professional Techniques for Digital Wedding Photography, *2nd Ed.*

Jeff Hawkins and Kathleen Hawkins

From selecting equipment, to marketing, to building a digital workflow, this book teaches how to make digital work for you. $29.95 list, 8½x11, 128p, 85 color images, order no. 1735.

Lighting Techniques for High Key Portrait Photography

Norman Phillips

Learn to meet the challenges of high key portrait photography and produce images your clients will adore. $29.95 list, 8½x11, 128p, 100 color photos, order no. 1736.

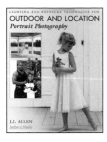

LIGHTING AND EXPOSURE TECHNIQUES FOR
Outdoor and Location Portrait Photography

J. J. Allen

Meet the challenges of changing light and complex settings with techniques that help you achieve great images every time. $29.95 list, 8½x11, 128p, 150 color photos, order no. 1741.

Toning Techniques for Photographic Prints

Richard Newman

Whether you want to age an image, provide a shock of color, or lend archival stability to your black & white prints, the step-by-step instructions in this book will help you realize your creative vision. $29.95 list, 8½x11, 128p, 150 color and b&w photos, order no. 1742.

The Art and Business of High School Senior Portrait Photography

Ellie Vayo

Learn the techniques that have made Ellie Vayo's studio one of the most profitable senior portrait businesses in the US. $29.95 list, 8½x11, 128p, 100 color photos, order no. 1743.

The Best of Nature Photography

Jenni Bidner and Meleda Wegner

Ever wondered how legendary nature photographers like Jim Zuckerman and John Sexton create their images? Follow in their footsteps as top photographers capture the beauty and drama of nature on film. $29.95 list, 8½x11, 128p, 150 color photos, order no. 1744.

The Art of Black & White Portrait Photography

Oscar Lozoya

Learn how Master Photographer Oscar Lozoya uses unique sets and engaging poses to create black & white portraits that are infused with drama. Includes lighting strategies, special shooting techniques and more. $29.95 list, 8½x11, 128p, 100 duotone photos, order no. 1746.

The Best of Wedding Photography

Bill Hurter

Learn how the top wedding photographers in the industry transform special moments into lasting romantic treasures with the posing, lighting, album design, and customer service pointers found in this book. $29.95 list, 8½x11, 128p, 150 color photos, order no. 1717.

Success in Portrait Photography

Jeff Smith

Many photographers realize too late that camera skills alone do not ensure success. This book will teach photographers how to run savvy marketing campaigns, attract clients, and provide top-notch customer service. $29.95 list, 8½x11, 128p, 100 color photos, order no. 1748.

Photographing Children with Special Needs

Karen Dórame

This book explains the symptoms of spina bifida, autism, cerebral palsy, and more, teaching photographers how to safely and effectively capture the unique personalities of these children. $29.95 list, 8½x11, 128p, 100 color photos, order no. 1749.

The Best of Children's Portrait Photography

Bill Hurter

Rangefinder editor Bill Hurter draws upon the experience and work of top professional photographers, uncovering the creative and technical skills they use to create their magical portraits. $29.95 list, 8½x11, 128p, 150 color photos, order no. 1752.

Wedding Photography with Adobe® Photoshop®

Rick Ferro and Deborah Lynn Ferro

Get the skills you need to make your images look their best, add artistic effects, and boost your wedding photography sales with savvy marketing ideas. $29.95 list, 8½x11, 128p, 100 color images, index, order no. 1753.

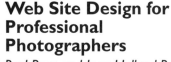

Web Site Design for Professional Photographers

Paul Rose and Jean Holland-Rose

Learn to design, maintain, and update your own photography web site. Designed for photographers, this book shows you how to create a site that will attract clients and boost your sales. $29.95 list, 8½x11, 128p, 100 color images, index, order no. 1756.

PROFESSIONAL PHOTOGRAPHER'S GUIDE TO
Success in Print Competition

Patrick Rice

Learn from PPA and WPPI judges how you can improve your print presentations and increase your scores. $29.95 list, 8½x11, 128p, 100 color photos, index, order no. 1754.

Step-by-Step Digital Photography

Jack and Sue Drafahl

Avoiding the complexity and jargon of most manuals, this book will quickly get you started using your digital camera to create memorable photos. $14.95 list, 9x6, 112p, 185 color photos, index, order no. 1763.

Take Great Pictures: A Simple Guide

Lou Jacobs Jr.

What makes a great picture? Master the basics of exposure, lighting, and composition to create more satisfying images. Perfect for those new to photography! $14.95 list, 9x6, 112p, 80 color photos, index, order no. 1761.

PHOTOGRAPHER'S GUIDE TO
Wedding Album Design and Sales

Bob Coates

Enhance your income and creativity with these techniques from top wedding photographers. $29.95 list, 8½x11, 128p, 150 color photos, index, order no. 1757.

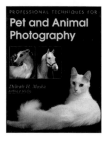

PROFESSIONAL TECHNIQUES FOR
Pet and Animal Photography

Debrah H. Muska

Adapt your portrait skills to meet the unique challenges of pet photography, creating images for both owners and breeders. Perfect for those who want to start a new pet portrait business or supplement their existing people-portrait business. $29.95 list, 8½x11, 128p, 110 color photos, index, order no. 1759.

The Best of Portrait Photography

Bill Hurter

View outstanding images from the industry's top professionals and learn how they create their masterful images. Includes tips and techniques on posing, lighting, composition, exposure, clothing, metering, and more. Features over 200 classic and contemporary images. $29.95 list, 8½x11, 128p, 200 color photos, index, order no. 1760.

Outdoor and Location Portrait Photography
2nd Ed.

Jeff Smith

Learn to work with natural light, select locations, and make clients look their best. Packed with step-by-step discussions and illustrations to help you shoot like a pro! $29.95 list, 8½x11, 128p, 80 color photos, index, order no. 1632.

The Best of Teen and Senior Portrait Photography

Bill Hurter

Teen and senior photography is a favorite genre for many photographers. In this book, top professionals show you how to create stunning images that capture the personality of their teen and senior subjects. $29.95 list, 8½x11, 128p, 150 color photos, index, order no. 1766.

PHOTOGRAPHER'S GUIDE TO
The Digital Portrait
START TO FINISH WITH ADOBE® PHOTOSHOP®

Al Audleman

Follow through step-by-step procedures to learn the process of digitally retouching a professional portrait. $29.95 list, 8½x11, 128p, 120 color images, index, order no. 1771.

The Portrait Book
A GUIDE FOR PHOTOGRAPHERS

Steven H. Begleiter

A comprehensive textbook for those just getting started in professional portrait photography. Covers every aspect of portraiture, from designing an image to executing the shoot. $29.95 list, 8½x11, 128p, 130 color images, index, order no. 1767.

The Master Guide for Wildlife Photographers

Bill Silliker, Jr.

Discover how photographers can employ the techniques used by hunters to call, track, and approach animal subjects to produce intimate portraits. Includes safety tips for wildlife photo shoots. $29.95 list, 8½x11, 128p, 100 color photos, index, order no. 1768.

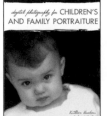

Digital Photography for Children's and Family Portraiture

Kathleen Hawkins

Discover how digital photography can boost your sales, enhance your creativity, and improve your studio's workflow. $29.95 list, 8½x11, 128p, 130 color images, index, order no. 1770.

Professional Strategies and Techniques for Digital Photographers

Bob Coates

Learn how the industry's top professionals—from portrait artists to commercial specialists—enhance their images with digital techniques. $29.95 list, 8½x11, 128p, 130 color photos, index, order no. 1772.

Lighting Techniques for Low Key Portrait Photography

Norman Phillips

Learn to create the dark tones and dramatic lighting that typify this classic portrait style. Covers metering, lighting, exposure, clothing and prop selection, and more. $29.95 list, 8½x11, 128p, 100 color photos, index, order no. 1773.

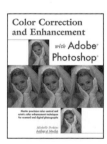

The Best of Wedding Photojournalism

Bill Hurter

Learn how top professionals capture these fleeting moments of laughter, tears, and romance. Features images from over twenty renowned wedding photographers. $29.95 list, 8½x11, 128p, 150 color photos, index, order no. 1774.

The Digital Darkroom Guide with Adobe® Photoshop®

Maurice Hamilton

Bring the skills and control of the photographic darkroom to your desktop with this complete manual and learn to produce the best possible fine art images. $29.95 list, 8½x11, 128p, 140 color images, index, order no. 1775.

Color Correction and Enhancement with Adobe® Photoshop®

Michelle Perkins

Master precision color correction and artistic color enhancement techniques for scanned and digital photos. $29.95 list, 8½x11, 128p, 300 color images, index, order no. 1776.

Fantasy Portrait Photography

Kimarie Richardson

Learn how to create stunning portraits with fantasy themes—from fairies and angels, to 1940s glamour shots. Includes portrait ideas for infants through adults. $29.95 list, 8½x11, 128p, 90 color photos index, order no. 1777.

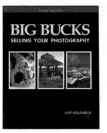

Big Bucks Selling Your Photography, *3rd Ed.*

Cliff Hollenbeck

Build a new business or revitalize an existing one with the comprehensive tips in this popular book. Includes twenty forms you can use for invoicing clients, collections, follow-ups, and more. $17.95 list, 8½x11, 144p, resources, business forms, order no. 1177.

Portrait Photography

THE ART OF SEEING LIGHT

Don Blair with Peter Skinner

Learn to harness the best light both in studio and on location, and get the secrets behind the magical portraiture captured by this award-winning, seasoned pro. $29.95 list, 8½x11, 128p, 100 color photos, index, order no. 1783.

Plug-ins for Adobe® Photoshop®

A GUIDE FOR PHOTOGRAPHERS

Jack and Sue Drafahl

Supercharge your creativity and mastery over your photography with Photoshop and the tools outlined in this book. $29.95 list, 8½x11, 128p, 175 color photos, index, order no. 1781.

Power Marketing for Wedding and Portrait Photographers

Mitche Graf

Pull out all of the stops to set your business apart and create clients for life with this comprehensive guide to achieving your professional goals. $29.95 list, 8½x11, 128p, 100 color images, index, order no. 1788.

Beginner's Guide to Adobe® Photoshop® Elements®

Michelle Perkins

Take your photographs to the next level with easy lessons for using this powerful program to improve virtually every aspect of your images— from color balance, to creative effects, and much more. $29.95 list, 8½x11, 128p, 300 color images, index, order no. 1790.

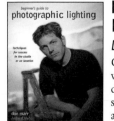

Beginner's Guide to Photographic Lighting

Don Marr

Create high-impact photographs of any subject with Marr's simple techniques. From edgy and dynamic to subdued and natural, this book will show you how to get the myriad effects you're after. $29.95 list, 8½x11, 128p, 100 color photos, index, order no. 1785.

Posing for Portrait Photography
A HEAD-TO-TOE GUIDE
Jeff Smith

Author Jeff Smith teaches sure-fire techniques for fine-tuning every aspect of the pose for the most flattering results. $29.95 list, 8½x11, 128p, 150 color photos, index, order no. 1786.

Professional Model Portfolios
A STEP-BY-STEP GUIDE FOR PHOTOGRAPHERS
Billy Pegram

Create portfolios that will get your clients noticed—and hired! Contains info on the modeling industry, photo techniques, and sample forms. $29.95 list, 8½x11, 128p, 100 color images, index, order no. 1789.

The Portrait Photographer's Guide to Posing
Bill Hurter

Get the posing tips and techniques that have propelled over fifty of the finest portrait photographers in the industry to the top. $29.95 list, 8½x11, 128p, 200 color photos, index, order no. 1779.

Master Lighting Guide for Portrait Photographers
Christopher Grey

Master traditional lighting styles and use creative modifications to light execturtive and model portraits, high and low key images, and more. $29.95 list, 8½x11, 128p, 300 color photos, index, order no. 1778.

Professional Digital Imaging
FOR WEDDING AND PORTRAIT PHOTOGRAPHERS
Patrick Rice

Build your business and enhance your creativity with the newest technologies, time-honored techniques, and practical strategies for making the digital transition work for you. $29.95 list, 8½x11, 128p, 150 color photos, index, order no. 1777.

Studio Lighting
A PRIMER FOR PHOTOGRAPHERS
Lou Jacobs Jr.

Create a temporary studio in your living room or a permanent one in a commercial space. Jacobs outlines equipment needs, terminology, effective lighting setups and much more, showing you how to create top-notch portraits and still lifes. $29.95 list, 8½x11, 128p, 100 color photos index, order no. 1787.

Professional Secrets of Natural Light Portrait Photography
Douglas Allen Box

Use natural light to create hassle-free portraiture. Beautifully illustrated with detailed instructions on equipment, lighting, and posing. $29.95 list, 8½x11, 128p, 80 color photos, order no. 1706.

The Art of Bridal Portrait Photography
Marty Seefer

Learn to give every client your best and create timeless images that are sure to become family heirlooms. Seefer takes readers through every step of the bridal shoot, ensuring flawless results. $29.95 list, 8½x11, 128p, 70 color photos, order no. 1730.

High Impact Portrait Photography
Lori Brystan

Learn how to create the high-end, fashion-inspired portraits your clients will love. Features posing, alternative processing, and much more. $29.95 list, 8½x11, 128p, 60 color photos, order no. 1725.